URBAN ART

THE WORLD AS A CANVAS

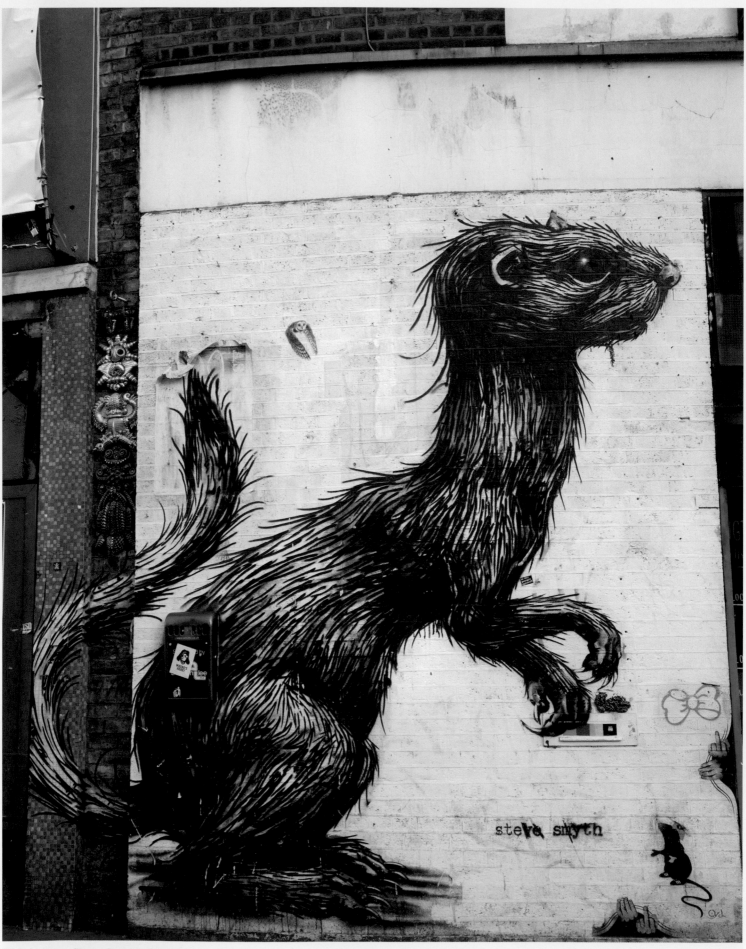

ROA, London Photo: Doralba Picerno

URBAN ART
THE WORLD AS A CANVAS

GARRY HUNTER

ARCTURUS

Front cover: Aryz, Barcelona

Back cover, from top:
Jimmy C, London
Os Gemeos, Boston
J B Rock, Rome
Edgar Mueller, Slovenia
Mr Brainwash, London
Gee, London
Paul 'Don' Smith, London

Author photo: Customs House, South Shields

ARCTURUS

This edition published in 2013 by Arcturus Publishing Limited
26/27 Bickels Yard, 151–153 Bermondsey Street,
London SE1 3HA

Copyright © 2013 Arcturus Publishing Limited

ISBN: 978-1-78212-050-6
AD002586EN

Printed in Singapore

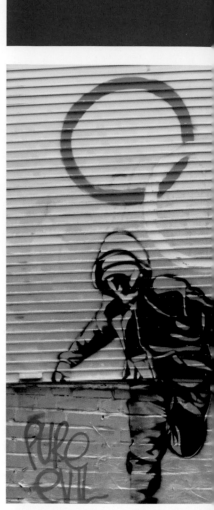

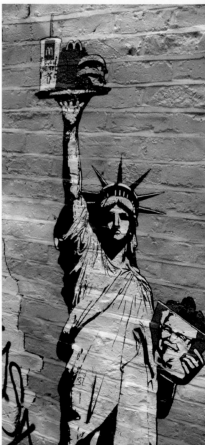

CONTENTS

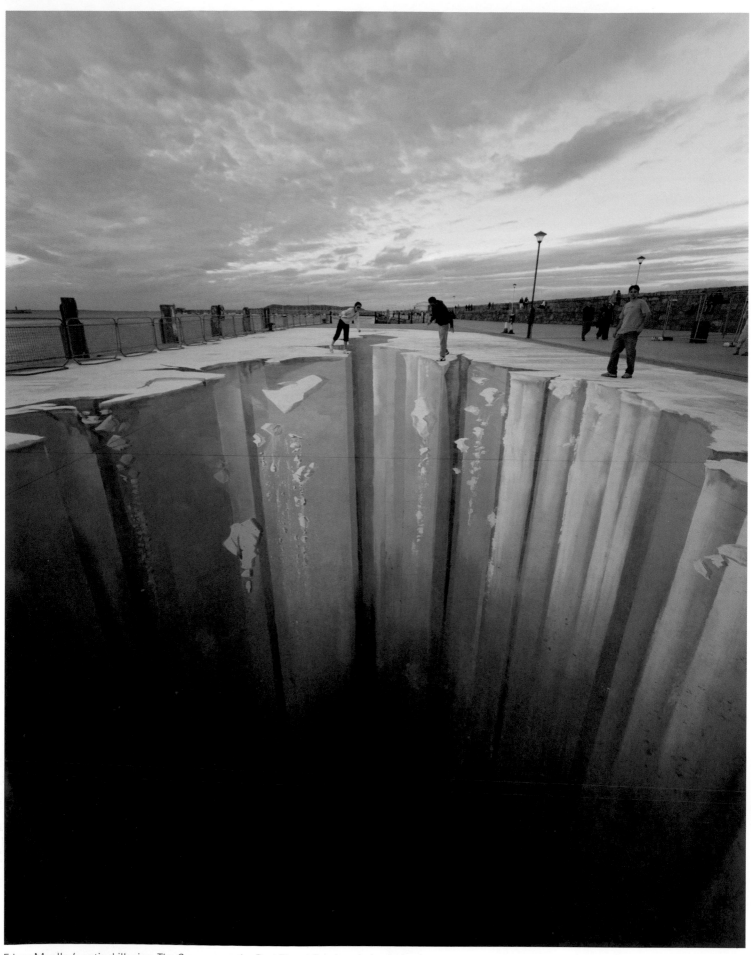

Edgar Mueller's optical illusion *The Crevasse* on the East Pier at Dun Laoghaire, Ireland

INTRODUCTION

Turn a corner in any city street today and you may be surprised to find a stunning piece of modern art adorning a wall or a door. This impromptu work may remain in place for just a few hours or for many months before it is removed, but it is a new and growing form of visual expression sweeping the world's cities. Urban art – the decoration of public spaces – is a combination of street art and graffiti and is often produced by artists who care passionately about the urban environment. Although this type of art started at a neighbourhood level, in areas where people of different cultures live together and where cross-fertilization of ideas takes place, it is now an international creative practice with a wide range of applications. Many urban artists travel from city to city and have social contacts all over the world.

This art speaks of contemporary urban cultural and political issues. In some examples, fragile mementoes mirror the fragmented, personal nature of human memory, selective in its retention of detail. Like memory, these pieces of art are susceptible to extreme conditions as well as to more slow and subtle changes. Other types of urban art demonstrate logic-defying juxtapositions that play with our spatial perceptions and provoke gasps of amazement from the onlooker.

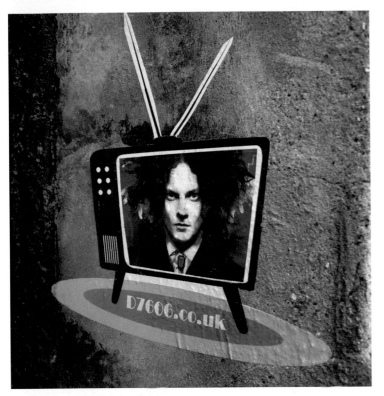

Jack White by D7606, London

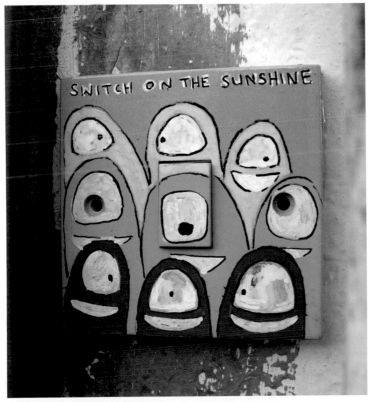

Reappropriated domestic light switch by Sophia Fox on a London street.

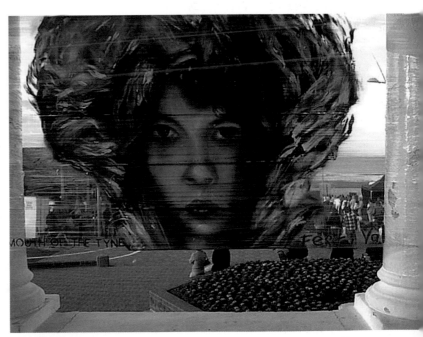

Cling Film graffiti at the Mouth of the Tyne festival, South Shields, UK

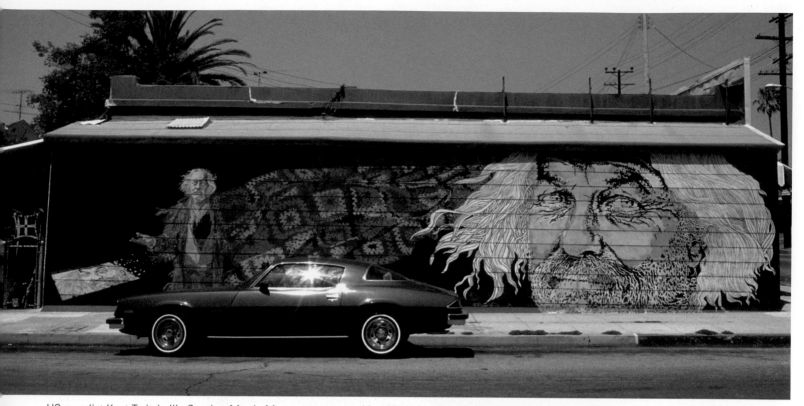

US muralist Kent Twitchell's *Strother Martin Monument*, executed in 1971 in Los Angeles, commemorates the movie actor. Photo: Peter Mackertich

Practitioners who bring art to public areas hope to alter the viewers' relationship with their surroundings, getting them to examine and question their own thought processes. Many of these artists want to challenge and confront establishment rhetoric and corporate greed. In times of austerity and conflict we tend to look for heroes, and urban art reflects this urge. Even if many of us do not recognize the heroic subjects depicted, we can appreciate the craft and emotion of the art and the courage and originality of its message.

In order to fund new projects, urban artists are increasingly selling works they originally placed on the street by making them available in galleries as editioned prints. The fact that some commissioned walls are paid for by community groups or institutions while others are paid for by the very corporations that some independent artists set out to challenge can result in a paradoxical state of affairs.

Dissenters decry street art as merely a passing trend, devoid of innovation. However, when the Museum of Contemporary Art (MoCA) in Los Angeles announced *Art in the Streets*, a large-scale exhibition featuring work from the 1970s to the present day, curator Aaron Rose observed: 'I don't think MoCA has done anything on this scale. The sheer number of kids who will come to this museum will be mind-blowing.'

Festivals of urban art such as this one in Azemmour, Morocco, attract practitioners from around the world. Photo: Annie Heslop

DIVIDED ORIGINS

In California, during the 1970s, photorealism took to the streets as huge paintings began to appear on the sides of buildings in Los Angeles. Largely apolitical in tone and executed in the dying embers of the American Dream, they illustrated aspirations of car ownership, eternal youth, technological advancement and a carefree life in the sun.

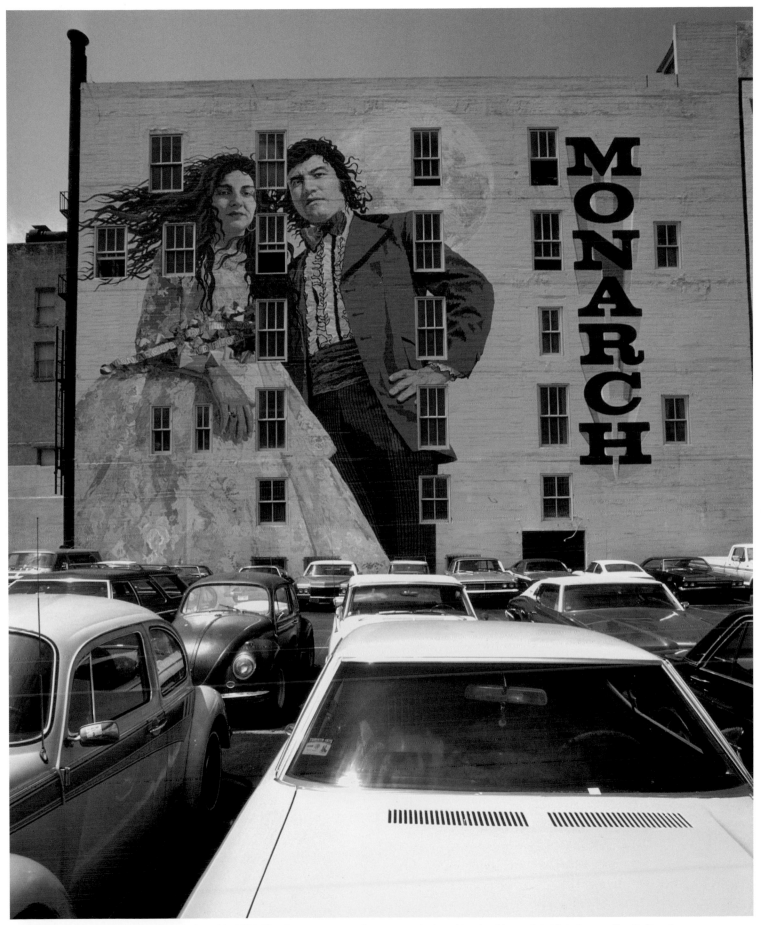

Twitchell's *Bride and Groom* was completed in 1976. The five-storey mural was commissioned by the Monarch bridal shop on South Broadway, Los Angeles. Photo: Peter Mackertich

THE CHICANO MURAL MOVEMENT

By contrast, in outlying areas of Los Angeles, activists such as Artistos Chicanos and Residentos Unidos worked with Hispanic communities to continue the Latin American tradition of mural painting. This method of delivering art to working-class Chicano communities consisted of covering bare concrete with images that aimed to inspire unity, consciousness and hope. Mural painting gave self-taught artist Ernesto de la Loza space to take chances, develop his style and explore cultural experiences that were largely invisible to the wider world at the time.

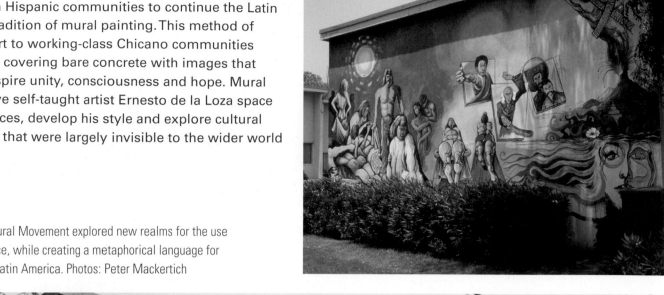

The Chicano Mural Movement explored new realms for the use of physical space, while creating a metaphorical language for migrants from Latin America. Photos: Peter Mackertich

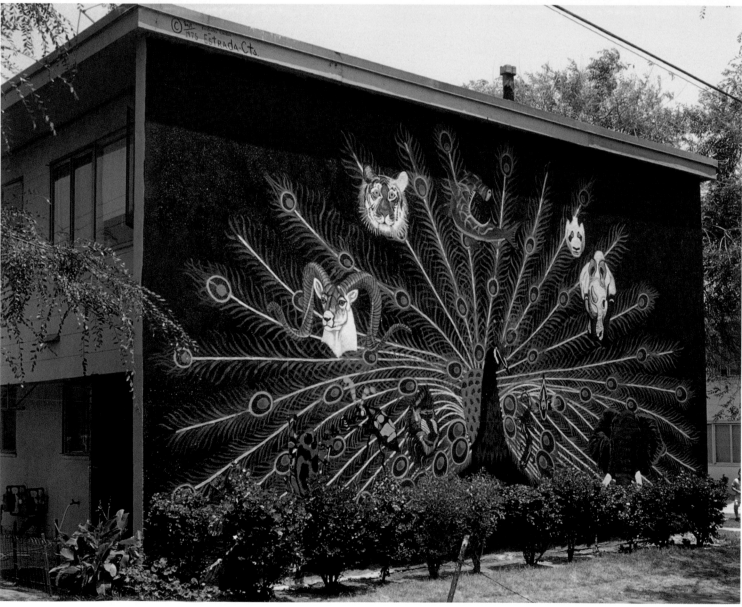

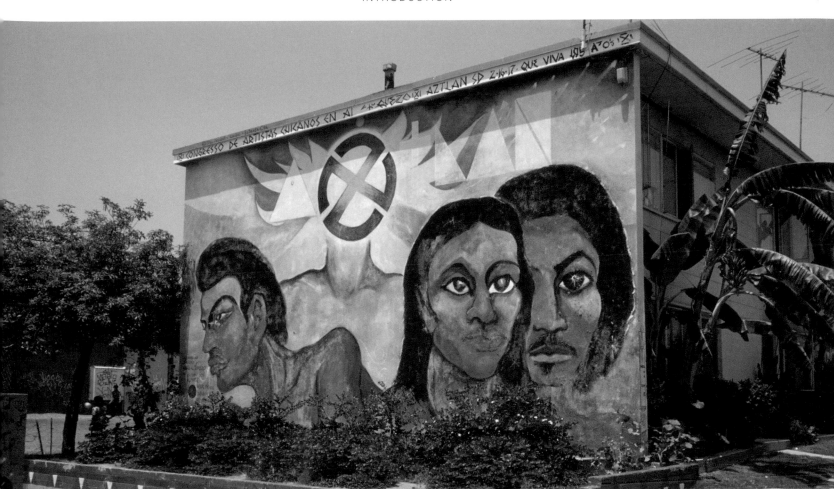

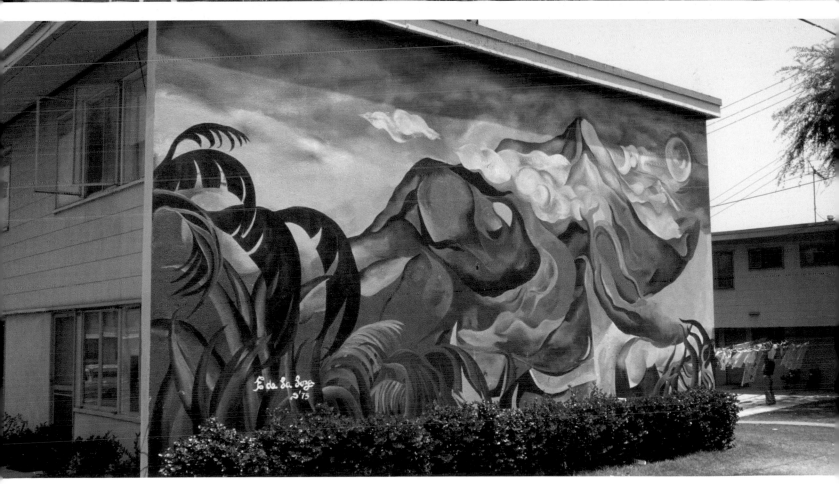

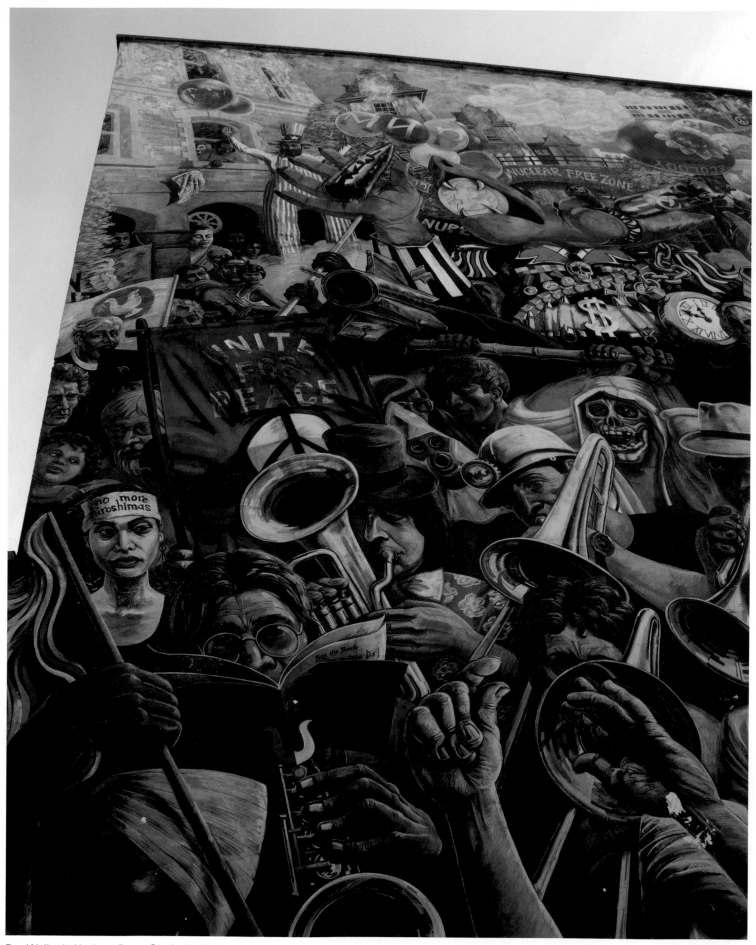

Ray Walker's *Hackney Peace Carnival 1983*, London

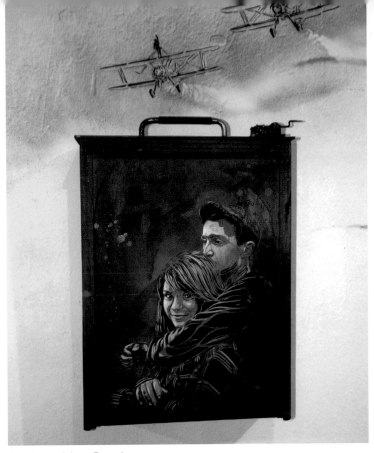

C215's musicbox, Barcelona

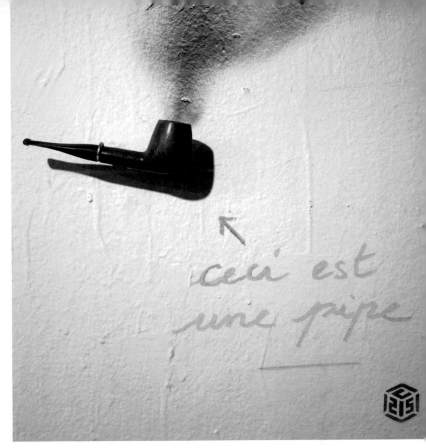

C215's homage to René Magritte, Barcelona

Meanwhile, on the east coast of the United States, mass transport systems bore spray-painted intertwining texts that acted as ciphers between graffiti crews. At the same time, supersized sculptural commissions began to redefine public spaces in Chicago, New York and Philadelphia. Unbounded by gallery walls, pop art behemoths were enlarged to sit comfortably among high-rise buildings.

In Europe, the urban art aesthetic valued simplicity over complexity. Here a strong undercurrent challenged commercialism and convention and, by transmuting public spaces into artistic arenas, reclaimed the streets for personal expression. In 1980s Britain, as industry declined, many murals appeared championing the rights of ordinary people; these included Ray Walker's *Hackney Peace Carnival 1983*. Although the artist died in 1984, many people felt that the mural was too important to be left to disintegrate and it was refurbished years later using modern paints.

Today, concepts from both sides of the Atlantic imbue the genres of global urban art examined in this book: iconic representations; illusory techniques; homage; pastiche; a focus on local issues, very often as synonymous with world issues; and emerging practices that utilize new materials and experiment with elements of kinetica, interaction and performance, some of which reference past masters. In a show featuring street signage and postal boxes hosted by

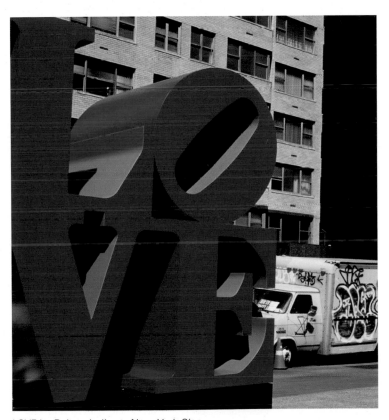

LOVE by Robert Indiana, New York City

Montana Spray Paint's gallery in Barcelona, C215 paid homage to Magritte's *Ceci n'est pas une pipe*, continuing to challenge observers' perceptions of reality and introducing music-box mechanisms to found objects bearing his recognizable stencil style.

THE FIRST STREET ARTIST

Modern urban art, as we know it, began in the mid-1960s with the work of Ernest Pignon-Ernest, a working-class practitioner born in 1942 in wartime Nice. Considered by many academics and artists to be the precursor of what has become a truly global movement, Pignon-Ernest remains largely unknown in the English-speaking world. Using cities such as Paris and Naples as his playground, he immerses himself in local culture and traditions, tapping into what he described at a Courtauld Institute of Art forum in 2012 as an 'attempt to perceive the invisible or no longer visible: history, hidden memories and symbolic dimensions.'

Activist interventions came to the fore in Paris during the 1968 international protests with the Situationists and Fluxus, a groundbreaking multimedia art movement that included visual art practices alongside literature, urban planning and architecture. This poetry of the metropolis fused Dada with the DIY ideals of the Fluxus founder, Lithuanian-born George Maciunas. Maciunas was colour-blind and it is no coincidence that the posters of this movement were usually monochrome, which probably influenced the stencil artists emerging in the 1970s who worked mainly with black paint alone.

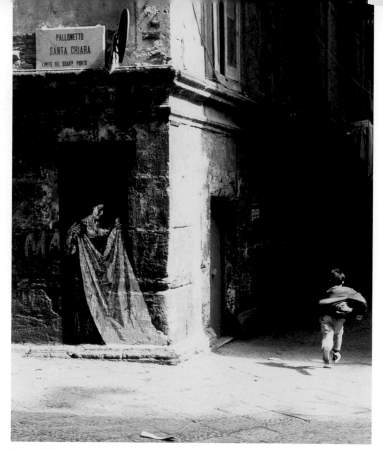

Ernest Pignon-Ernest's ghostly posters, pasted up nocturnally, trace ancient routes of religious, social and political significance. Themes of Christian and pagan worship feature strongly in his work. Photos: by artist

In this Neapolitan work titled *Soupirail* ('Basement Window'), Pignon-Ernest sensitively denotes rites of life and death with a delicately printed cadaver, referencing the radical naturalism of 16th-century painters and the black lava that entombed nearby Pompeii and Herculaneum in AD79.

A street portrait in Bangalore, India

Urban art as performance: an anti-GM march in India

Dada is alive and well in India

WHO OWNS ART ON THE STREET?

Walls daubed with slogans and arresting graphic imagery are now
a familiar sight in cities around the world. The modern urban art
movement utilizes rapidly scrawled tags, meticulously layered
paintworks, cleverly observed juxtapositions and other pioneering
methods of communication that seep into the collective consciousness.

A modified ad hoarding in Dalston, London

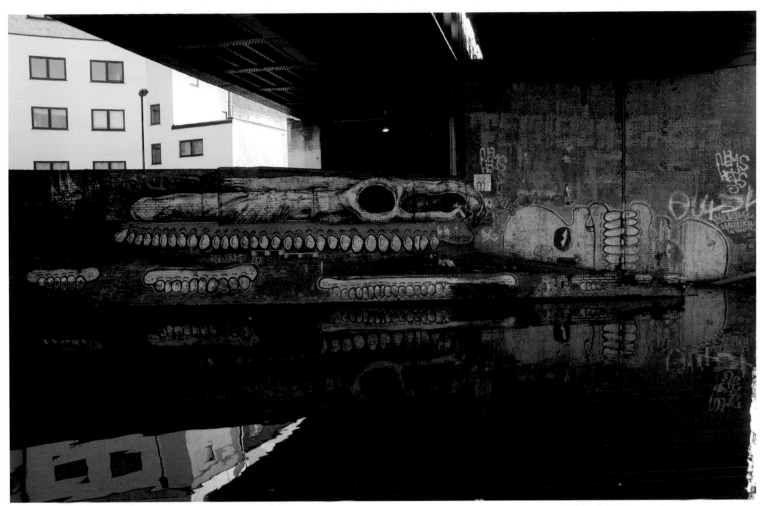

ROA and Sweet Toof's work on the Regent's Canal in London

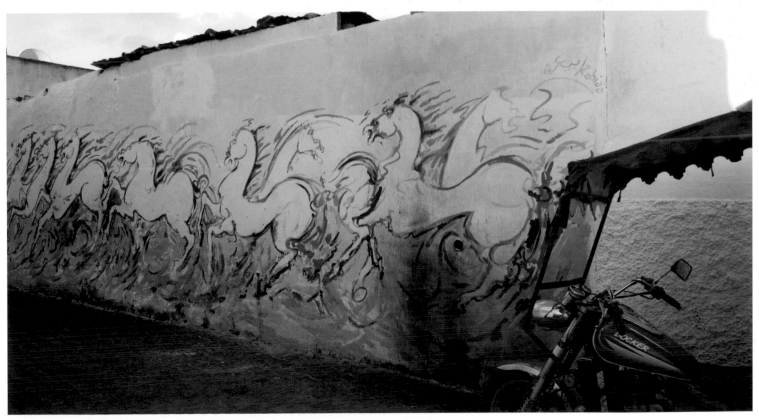

A stampede of pale horses across a wall by Kabiaz, at the Azemmour Visual Arts Annuale, Morocco

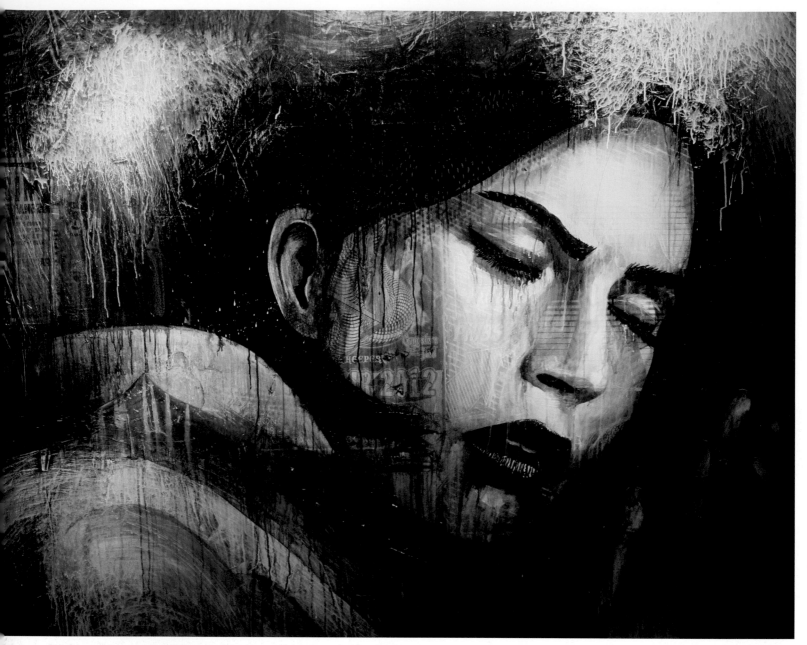

Melbourne-based artist Rone uses found text off the street in his urban art

ART VERSUS COMMERCE

The ad hoardings that dominated our late 20th-century skylines now vie for attention with walls decorated by artists who have been hired to carry out commissions by multinational advertising companies. This art-directed gentrification of rundown former manufacturing sites and neglected railroad depots is perceived, mistakenly, as a grassroots movement. In fact it serves to reinforce the credibility of social media agencies and fulfils their desire to be seen as leading trendspotters. However, in the world's fourth-largest metropolis, art is taking precedence over commerce. In 2007 the mayor of Sao Paulo, Brazil, banned outdoor advertising hoardings in a move that opened up many new walls for the city's artistic community.

Because it is in the public domain, urban art is often reproduced without regard for copyright. This means that art painted on an advertising hoarding may be appropriated commercially by the very company whose practices it has set out to challenge. Also, while it is illegal to place art in public spaces, it is not illegal to take it down. Art is often removed by individuals including officials, developers and collectors. For this reason, some urban artists are moving indoors, where they can exercise a degree of control over the use of their intellectual property.

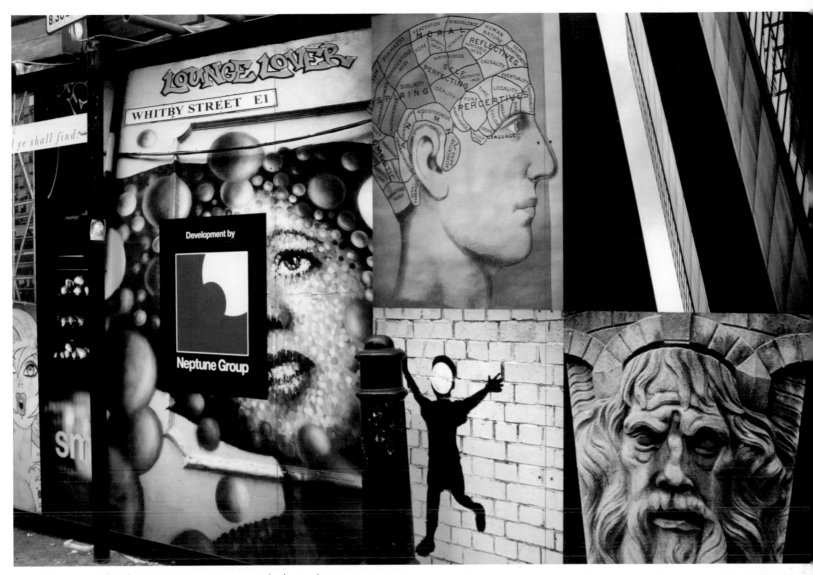

A London property developer uses street art as a marketing tool

Donk, London

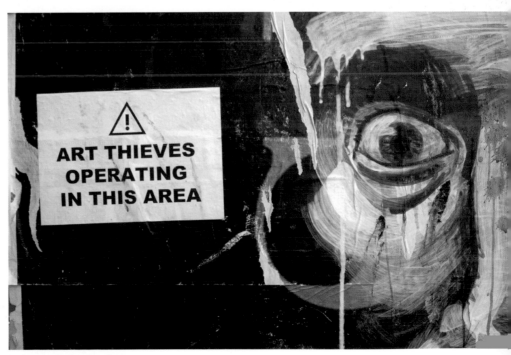

Unknown artist, London

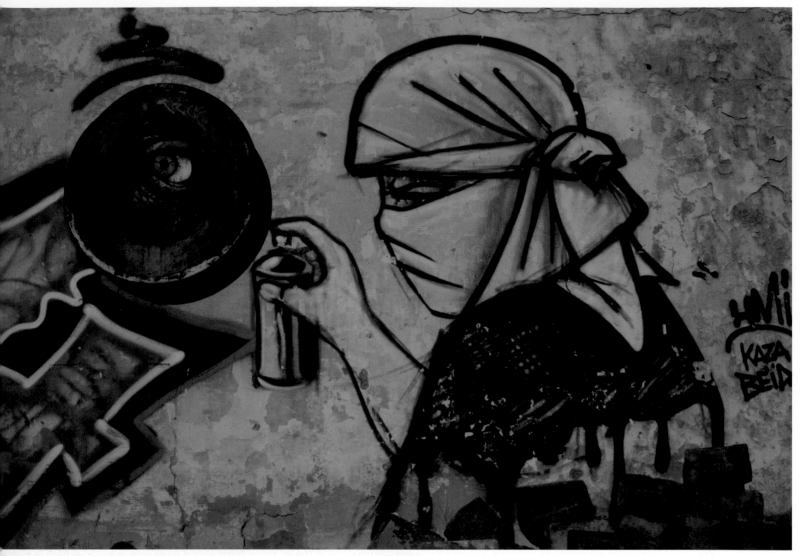

Sprayed wall by a female artist in Morocco

David Cerny's Czech House, London Photo: Doralba Picerno

FROM STREET TO GALLERY

While many outdoor artists are coming in from the cold, other established gallery-bound artists have started working al fresco. And, while superstar architects build steel-and-glass mausoleums to house private art collections, savvy independent gallerists requisition cavernous, disused buildings and use them as a blank, aged canvas. Former warehouses which, until relatively recently, had illegal artwork displayed on their external walls now host indoor exhibitions by urban artists. Redolent of an industrial past, these dilapidated interiors, with their bare, functional brickwork and vestiges of ancient storage systems are well suited to the housing of brightly painted 'streetritus' (street detritus). In these reappropriated exhibition spaces, artworks are made by applying paint to railings, cardboard, car parts and other found materials. The works are hung in whatever way the artists want (sometimes from ceiling fittings) and can be installed in less time than it takes for an overzealous property owner to paint over an illegal work on the

A portrait of Robert Rauschenberg, London

Pluvial Waters by ZEZAO, London

street. These fleeting opportunities to view urban art indoors are a further comment on the ephemeral nature of the installations, whether they are inside or outside city buildings.

THE ONGOING DEBT TO POP ART

Warholism abounds in the ambitiously staged installations by Mr Brainwash (MBW), which tick the boxes of every pop artist from Richard Hamilton to Ed Ruscha, with a nod to Robert Rauschenberg, Roy Lichtenstein, Jean-Michel Basquiat, Keith Haring et al along the way. As part of a series of bold exhibitions, the MBW team covered the outside of the former West Central mail sorting office in London and decorated the entire ground floor and former loading bays. Ranks of besuited doormen strictly monitored the allocation of free posters and spray-can souvenirs.

A mystery still remains as to how such a huge exhibition could have been funded and who made the large amount of artwork on display. Was it a team of graphic designers or (as has been rumoured) is MBW merely the alter-ego of celebrated elusive street artist Banksy?

In *Exit Through the Gift Shop*, documentary meets satire, as Banksy's first film balances self-effacement with hubris in its portrayal of the ostensible subject MWB (aka Thierry Guetta) who travels to Los Angeles to make it big as an urban artist.

URBAN ART AS COMMODITY

It is becoming difficult to distinguish independently produced work from preconceived campaigns, as febrile activity in some city centres means that an undecorated surface is a rarity. In recent years, companies such as Street Art London have expanded their guided tours of London's East End to take in the urban art of Berlin. These cosy package tours of the city's veneers have little connection with the origins of protest that made the west side of Berlin a focus for political murals when the Wall divided it from the east. The German capital today is a hotbed of contemporary art, with studio rents only just starting to rise as the city becomes popular with the weekend getaway hordes.

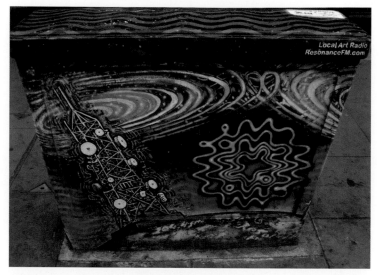

A street ad for Resonance radio, London

Kurz Nach Zehn, Berlin

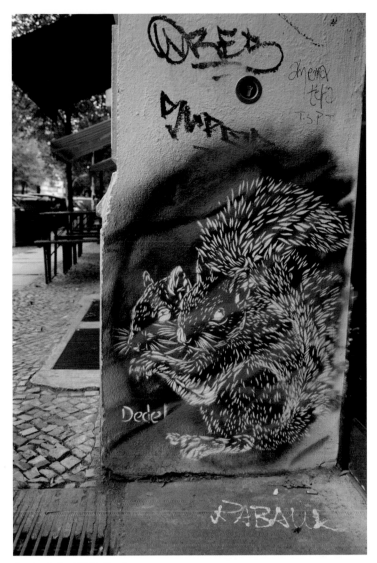

Squirrels by DEDE, Berlin

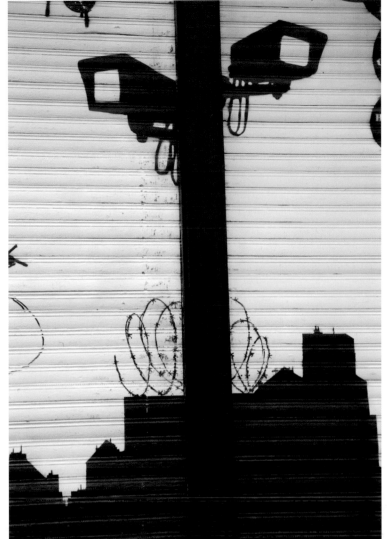

Unknown artist, Berlin

Right: BOXI, Berlin

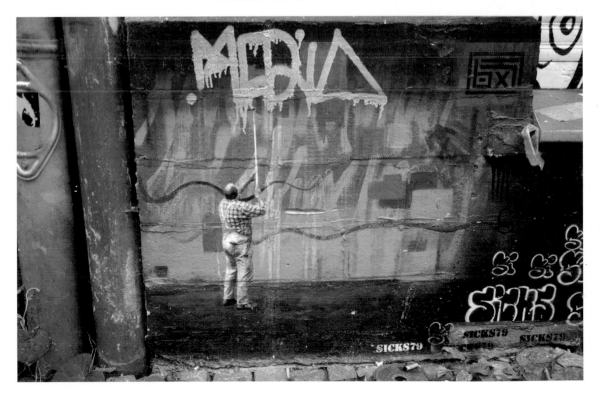

All Berlin photos: Doralba Picerno

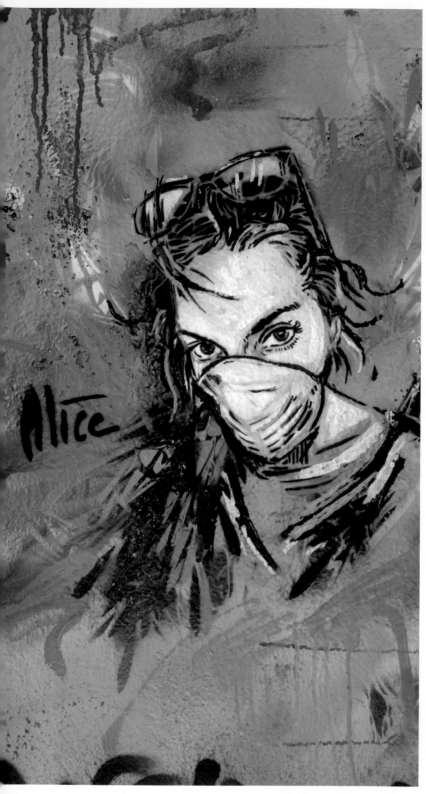

Self-portrait by Alice, Rome

WHAT MAKES AN URBAN ARTIST?

Artistic talent, motivation, originality and independence of thought ensure that an emerging urban artist will stand out from his or her peers. Shrewd eloquence is also vital in order to communicate ideas to the viewer quickly, effectively and with an emotional punch. A successful urban artist is therefore likely to possess a mercurial temperament. In Roman mythology, the celestial messenger Mercury was the god of travel, thievery and commerce and he is an ideal source of inspiration, encapsulating the urban artist's swift-footed, often illegal and, increasingly, commercial traits. How long before a winged Mercury appears as an urban artist's tag?

Because of the questionable legal status of much urban art, its proponents often choose to keep their identities secret. Anonymity has become a foil against arrest for many urban artists; they sign their work with a pseudonym and wear sunglasses, hooded sweatshirts, hats pulled down over their heads and scarves over their faces. For spray-can artists, the face-mask serves a dual purpose as a protective shield and to obscure recognizable features. It has become an element in homage portraits of urban art heroes and sometimes in self-portraits of the artists themselves, who appear mysteriously, like the legendary Zorro, armed with a pen that is mightier than the sword.

Unknown artist, London

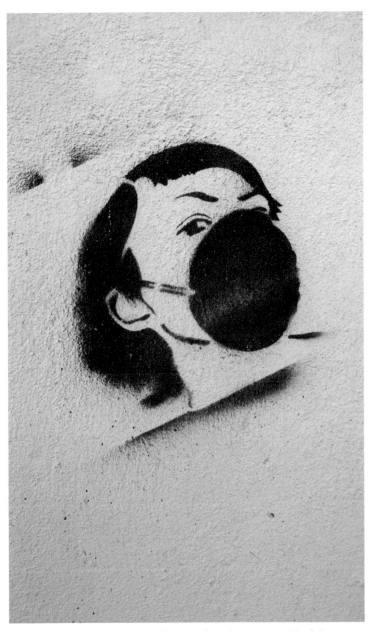

Unknown stencil artist, Cadiz; this piece has also appeared in Cairo

PRESERVING URBAN ART THROUGH PHOTOGRAPHY

Photography plays an important role in documenting the evolution of urban art. New Zealand photographer James Gilberd says documenting street art is vital, as the art, by its very nature, is transient: 'Even the murals have a lifespan – the building gets knocked down, another mural covers it, or they just repaint the wall. It's good to record it because in ten years probably none of this stuff will be there.'

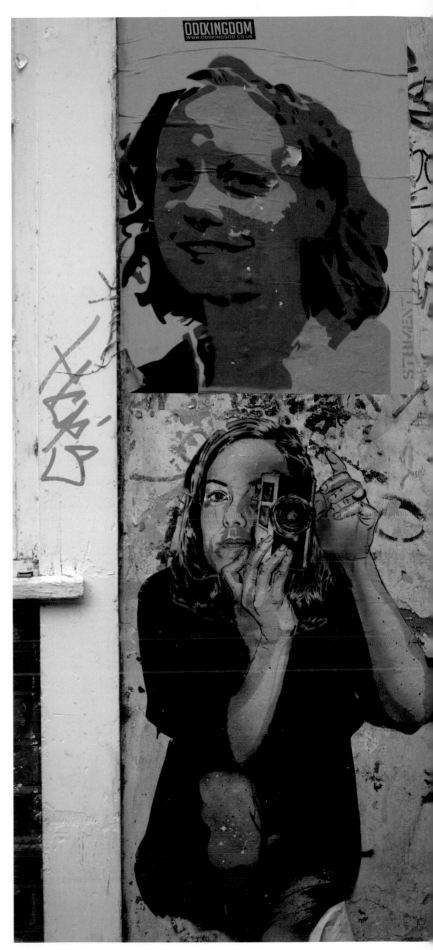

Camera Girl by JANA und JS, London

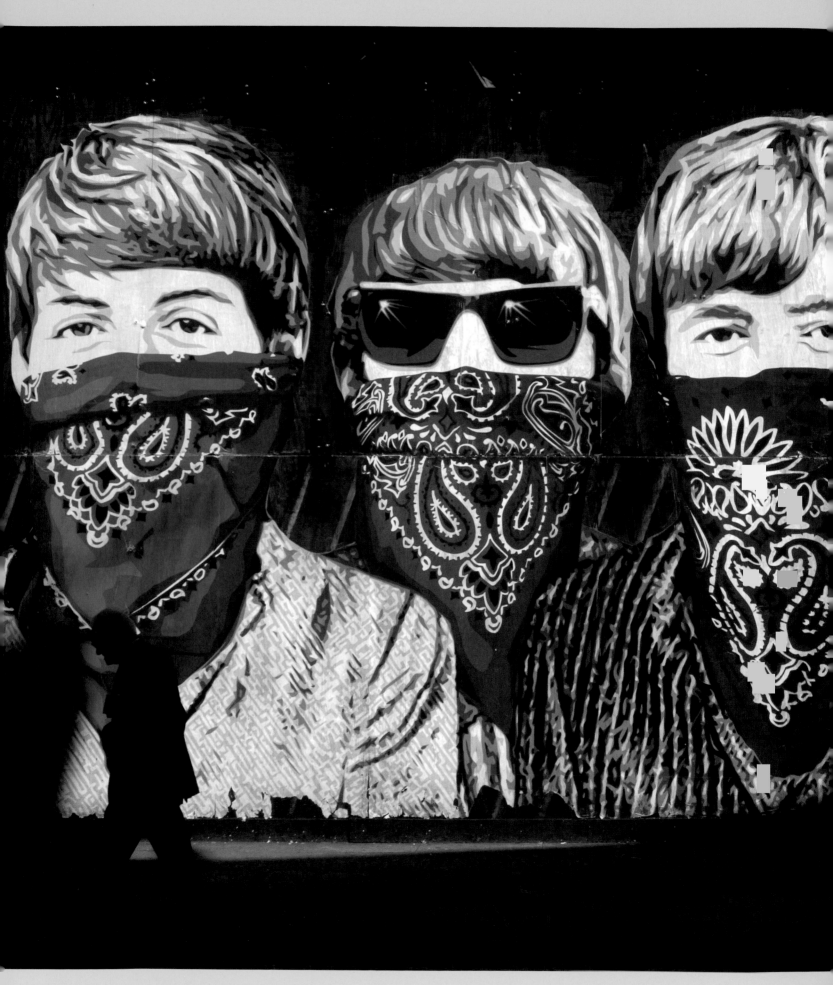

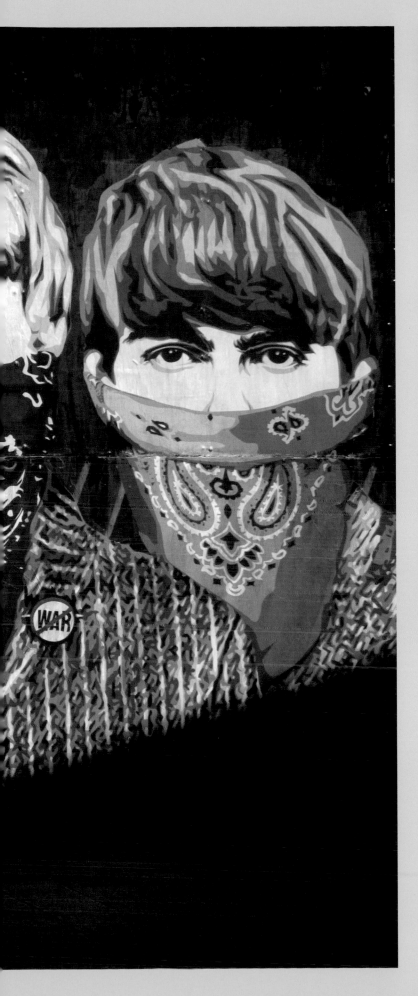

ICONS

There is a burgeoning trend for artists to produce work featuring their heroes. This may be in the shape of a single piece of urban art or a whole wall of interlinking portraits, like this mural of the Beatles by Mr Brainwash. While many artists offer personal interpretations of legends such as Yuri Gagarin, Jimi Hendrix, Frida Kahlo and Sergio Leone, some are increasingly rendering family members as icons in a kind of personal homage. American cartoon characters, manga heroes and computer gaming avatars also feature as icons, inviting viewers to identify with the artist's passion, whether for an obscure subcultural magazine or a globally recognized figure. Spiritual legends, ranging from Native American leaders to early Christian prophets, are also popular iconic subjects, gazing down from their elevated positions on high walls and viaducts.

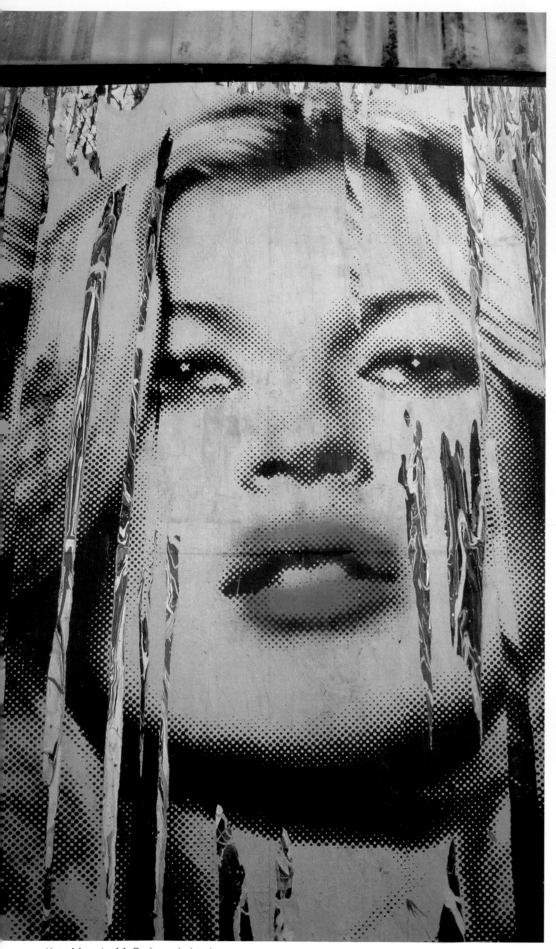

Kate Moss by Mr Brainwash, London

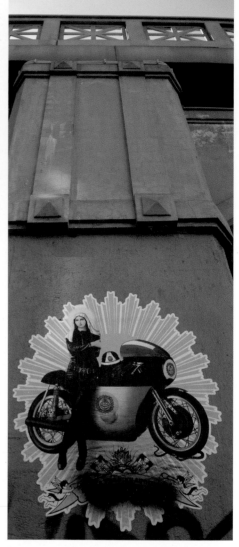

Biker art by Maria Vergine Augusta, Rome

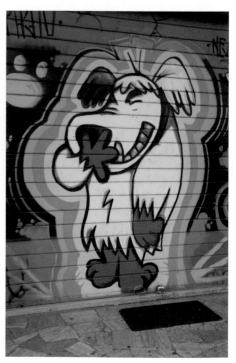

Muttley by an unknown artist, Rome

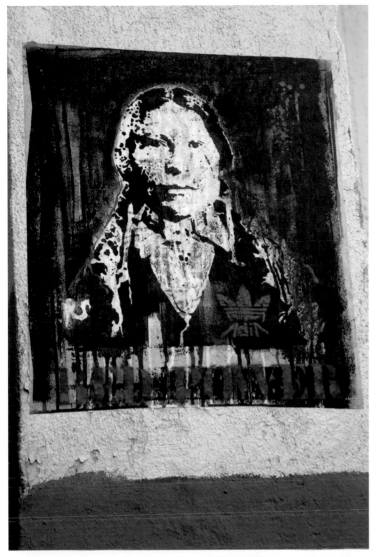

A Native American icon by Idi1 Red Power, Marseille

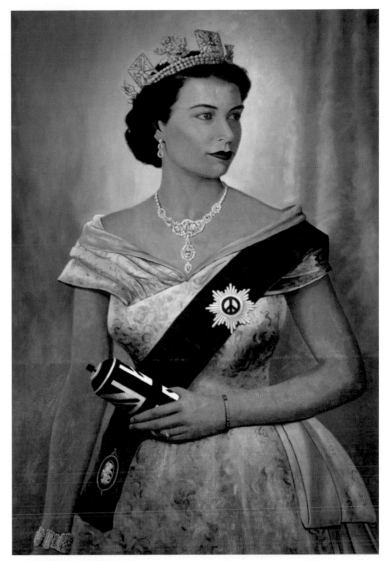

The British monarch realized by Mr Brainwash, London

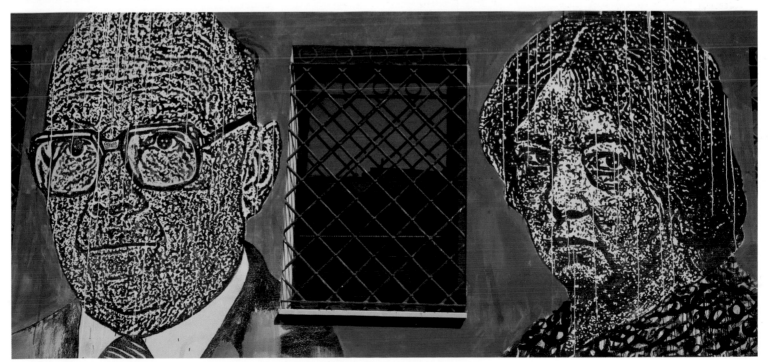

German politician Erich Honecker and Indian Prime Minister Indira Gandhi by Sten & Lex, Rome

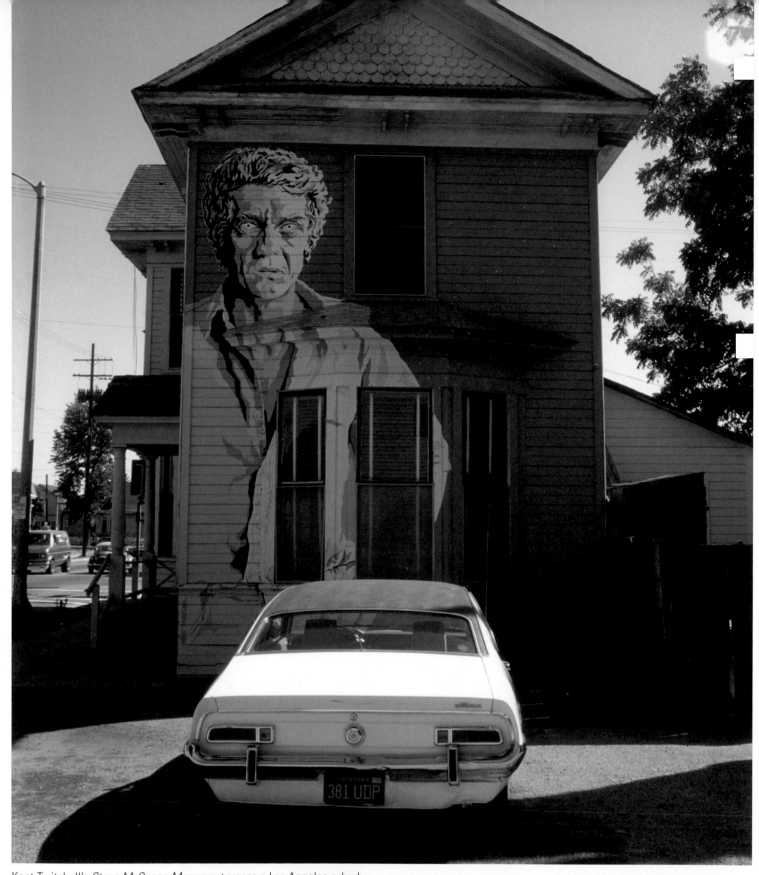

Kent Twitchell's *Steve McQueen Monument* graces a Los Angeles suburb.

In the late 1960s, some of the most striking large-scale iconic works were produced by American artist Kent Twitchell. During the earlier years of the decade Twitchell had served in the US Airforce; a posting to London had enabled him to absorb the revolutionary visual art being produced in the city at that time. Back in the USA, he took advantage of the GI Bill to study at California State University in Los Angeles, where the city's sprawl would become his enduring focus. Twitchell's use of folk art motifs harks back to his boyhood on the family farm in Michigan. His murals often transpose famous actors onto clapboard buildings.

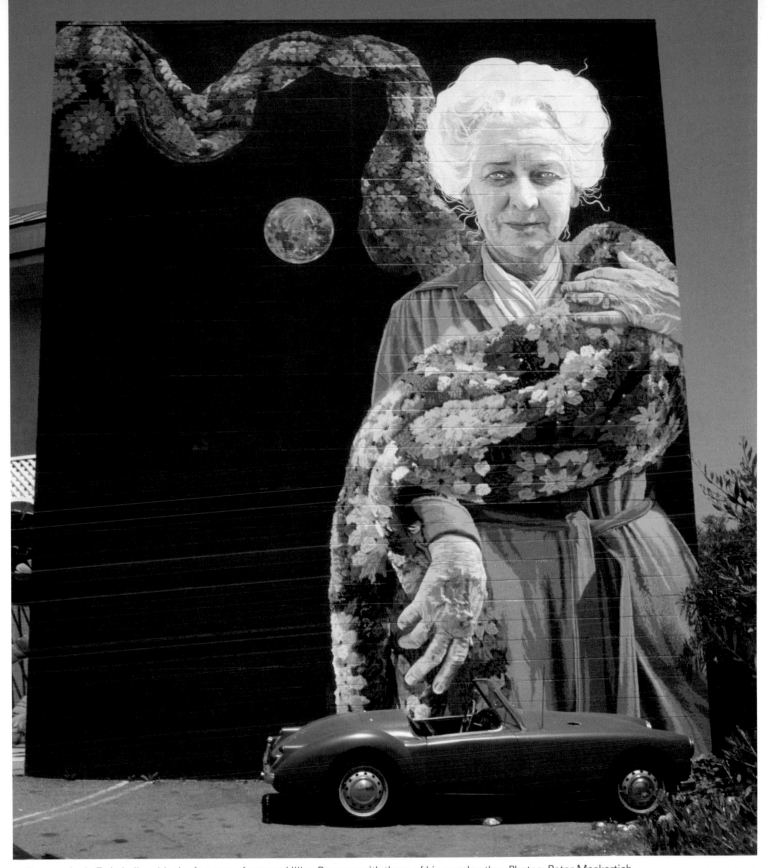

In *Freeway Lady*, Twitchell melds the features of actress Lillian Bronson with those of his grandmother. Photos: Peter Mackertich

However, *Freeway Lady* and many more of Twitchell's most lauded works no longer exist in their original locations. A recent reassessment of their significance has resulted in repeat commissions by institutions, but the artworks are now placed inside buildings for fear of vandalism. After officials sanctioned the painting over of Twitchell's *Ed Ruscha Monument*, the government was forced to provide compensation of more than $1m for violating the Federal Visual Artists' Rights Act and the California Art Preservation Act. These laws prohibit 'desecration, alteration or destruction of certain works of public art' without prior warning.

ICONS IN ITALY

In Rome, once-thriving industrial areas in the east of the city now host some of the most exciting world-class urban art. Here the Ostiense Project, one of the biggest regeneration programmes in Europe, is paving the way for a huge university, a theatre, a cavernous bookshop and a contemporary art museum. Vast tracts of land are being redeveloped, which may once again establish the city as a nucleus of western civilization. Just outside the walls of Ancient Rome, in a faded area formerly home to manufacture, power generation and a mercantile tradition, JB Rock's *Wall of Fame* is a permanent addition to the project.

Artist Frida Kahlo and filmmaker Sergio Leone from JB Rock's *Wall of Fame*

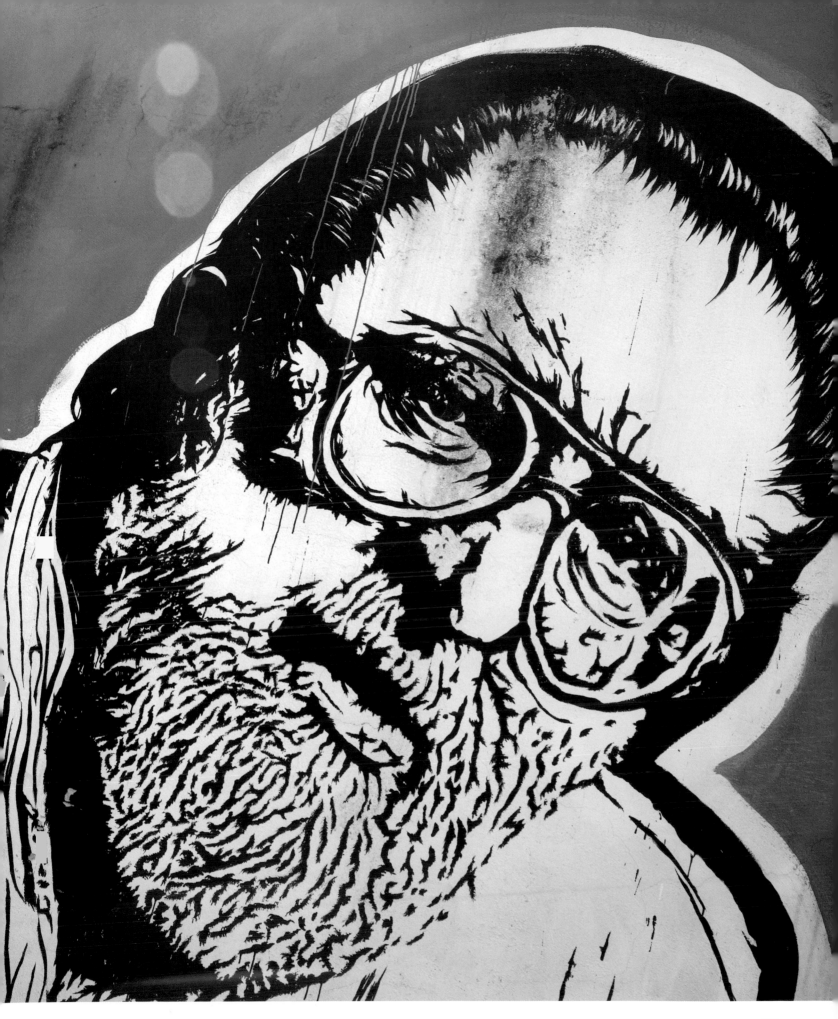

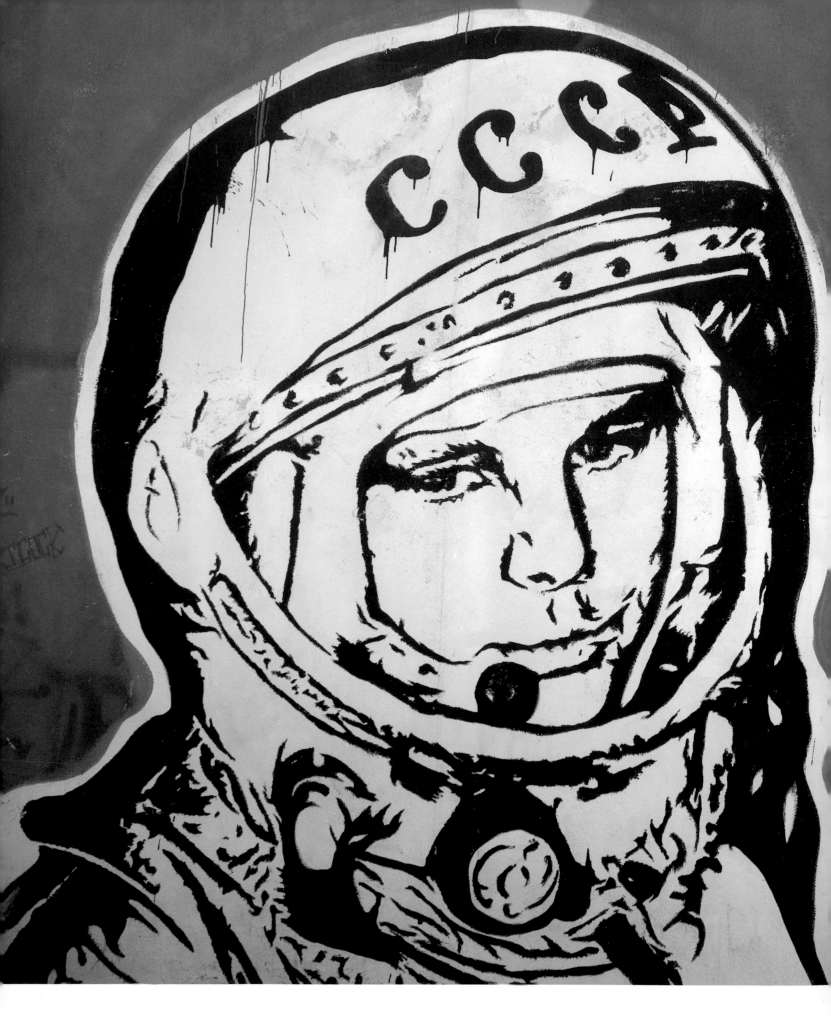

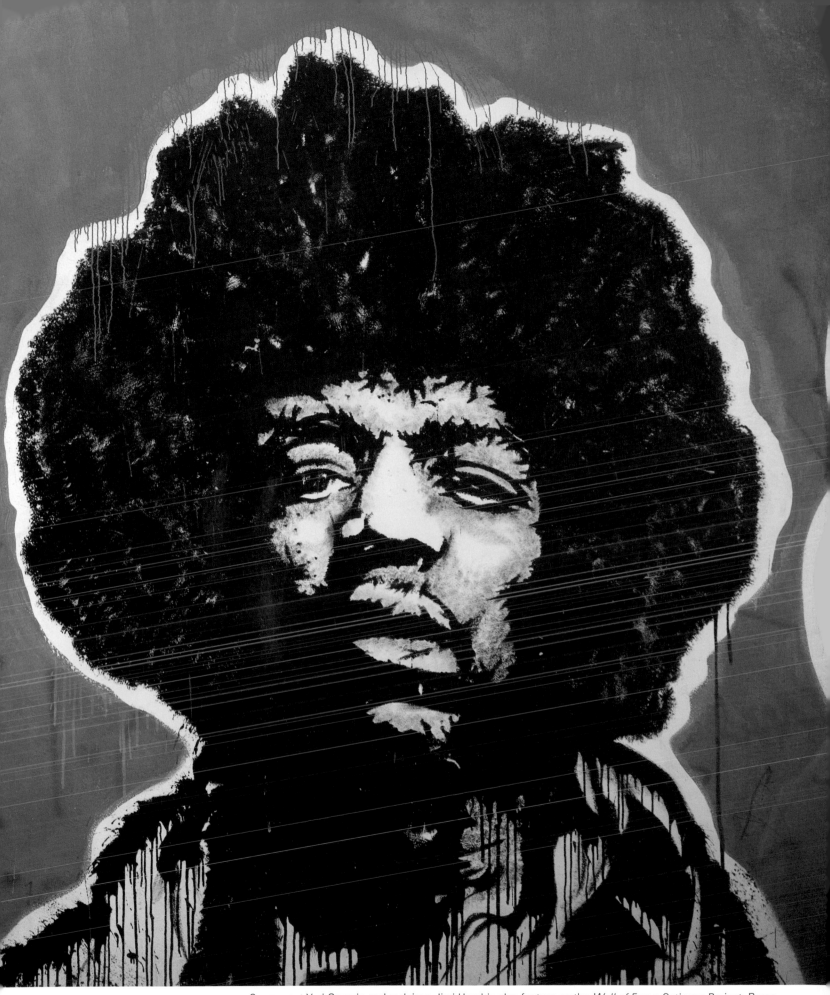

Cosmonaut Yuri Gagarin and rock icon Jimi Hendrix also feature on the *Wall of Fame*, Ostiense Project, Rome.

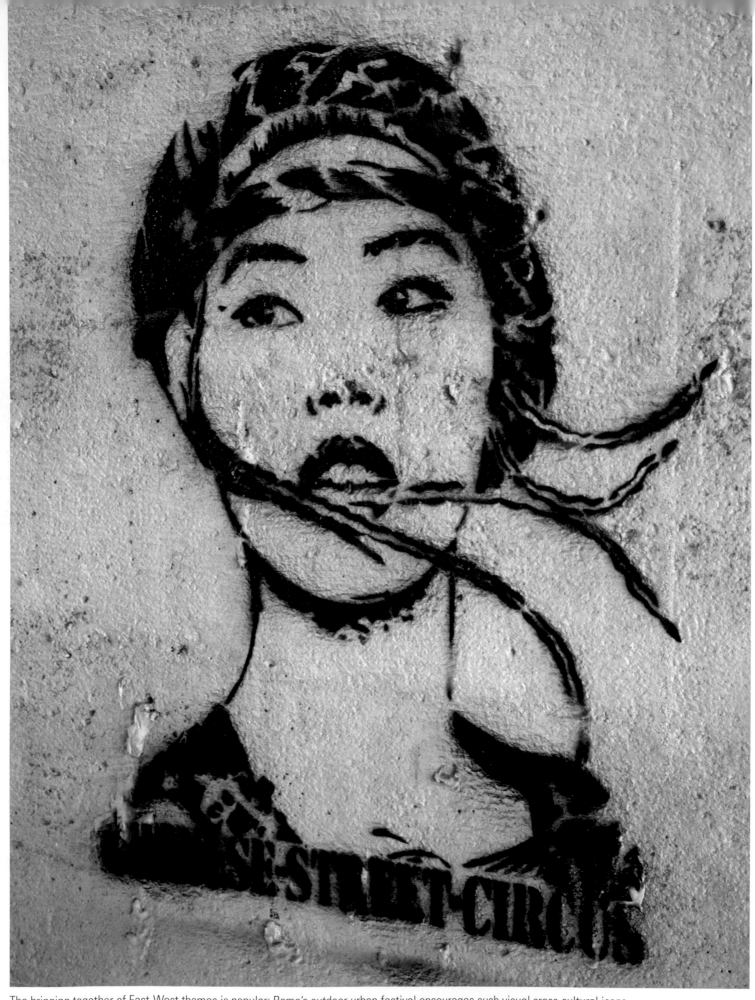

The bringing together of East-West themes is popular; Rome's outdoor urban festival encourages such visual cross-cultural icons.

Although a striking use of cinematic imagery, this *Village of the Damned* art would look more appropriate on a brick wall, given the significance of this structure in both film versions and in the original novel (*The Midwich Cuckoos* by John Wyndham).

An energized artefact by Gee: the sociopaths portrayed by actor James Cagney were classic anti-establishment figures, so it is fitting that his portrait should adorn a spray-can – the illegal street artist's weapon of choice.

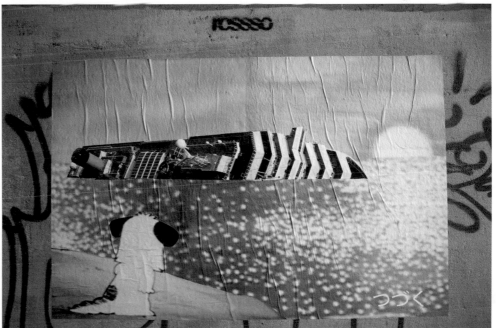

Rosso combines the tragic news image of the *Costa Concordia* disaster with an animé dog whose owner is lost at sea. In the 1980s, *Ohay* or *'Hello' Spank* was a popular cartoon across the non-English-speaking world. It featured the character Aiko, who waits for her father to return on a yacht that has gone missing. Gazing out at the overturned *Costa Concordia*, this canine sentinel considers how another disaster might have been avoided in the centenary year of the sinking of the *Titanic*.

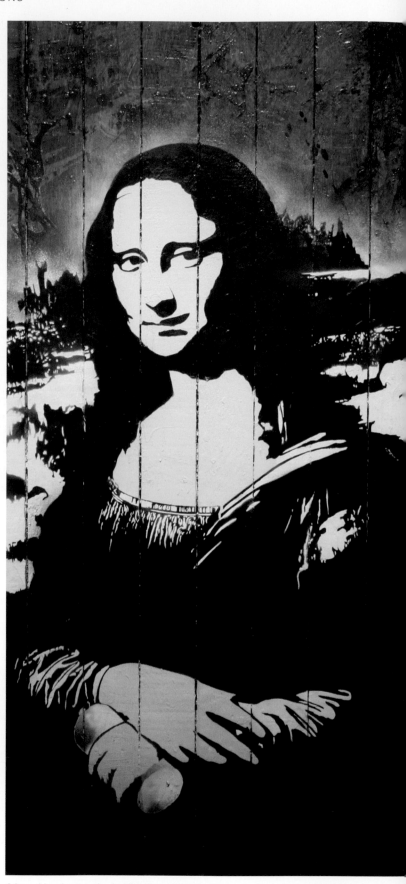

Casablanca, Morocco: John Goodman is seen as Walter Sobchak, Vietnam veteran and the Dude's bowling teammate in *The Big Lebowski*.

Mona Lisa, Leonardo da Vinci's understated masterpiece, is a subject that Parisian stencil pioneer Blek Le Rat has added to his canon.

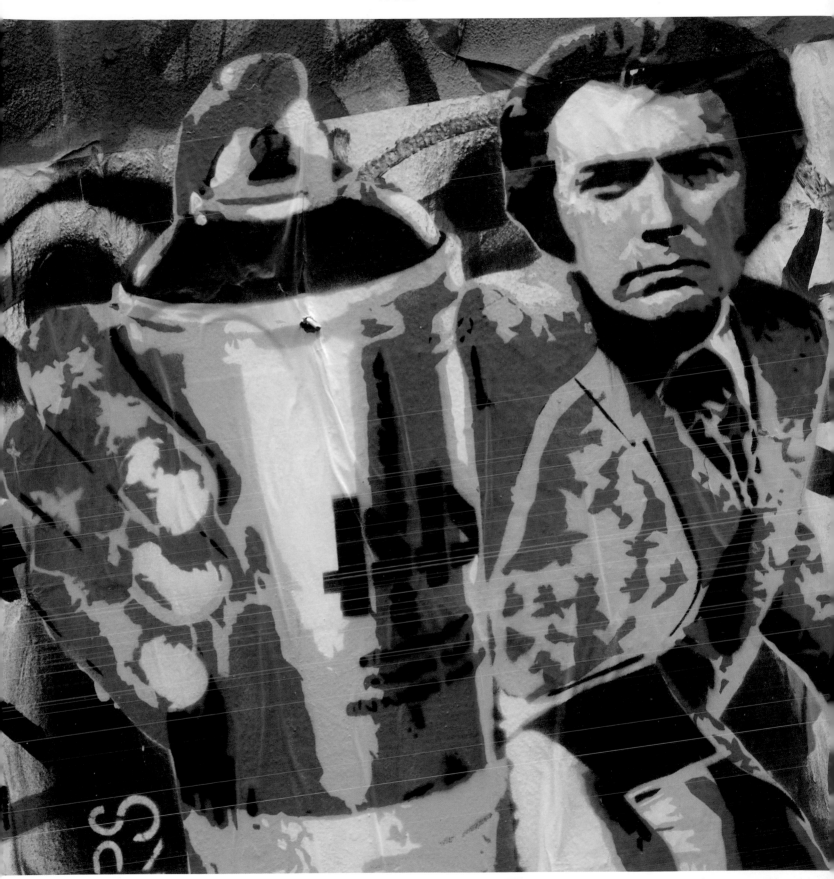

Paris, France: eponymous detective Dirty Harry makes some punk's day, but armed with a spray-can instead of a magnum.

PuP, POETRY AND POLITICS

The real and imagined come together in the strikingly clever stencils of emerging artist Icon, who is quickly establishing a reputation as a wry social commentator. His piece *Abduction*, which first appeared on a building site hoarding by the River Lea in east London on New Year's Day 2013, shows the ambitious pop icon Madonna in shopping mode, complete with designer bag and sunglasses, as she drags feral *Jungle Book* character Mowgli out of a nearby bush. This art comments on the star's penchant for adopting orphans from the developing world, but its placement also reminds people that this stretch of the river has been closed off by the hoarding of a still unfinished development which has marred the route of walkers for many years.

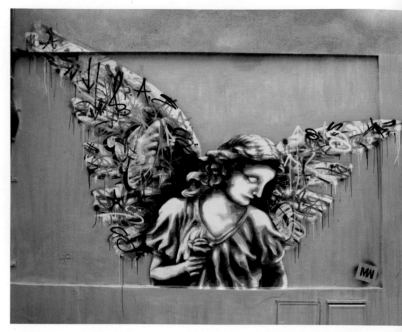

Paris, France: Most Wanted have created this angel in the Belleville district.

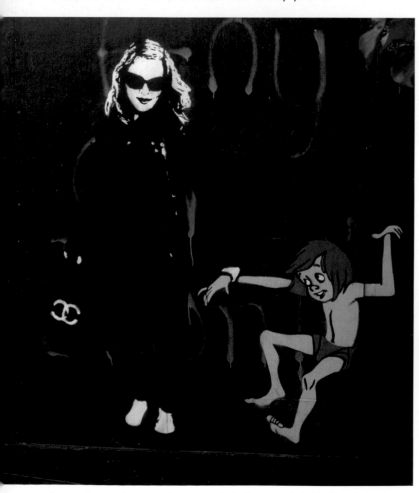

Icon subverts the eternal concept of Madonna and child with *Abduction* on an east London hoarding.

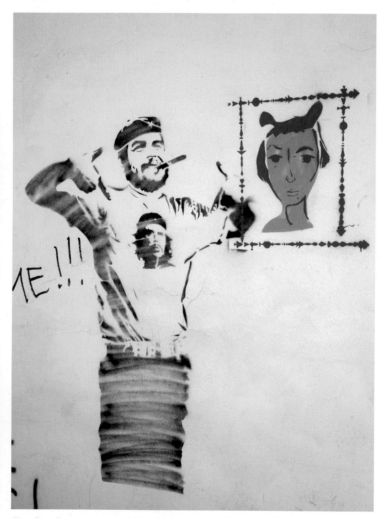

The Che Guevara portrait that has adorned the walls of millions of bedroom revolutionaries is probably the most reproduced photograph ever. Here it is cleverly utilized by Norway's most revered stencillist, Dolk ('Dagger'), who shows Che on a T-shirt worn by a triumphant young Fidel Castro.

Early Christian icons sit amid pop culture in the 'Eternal City' of Rome, often morphing into more thoroughly modern work. The inverted names of the artists are sometimes more difficult to decipher.

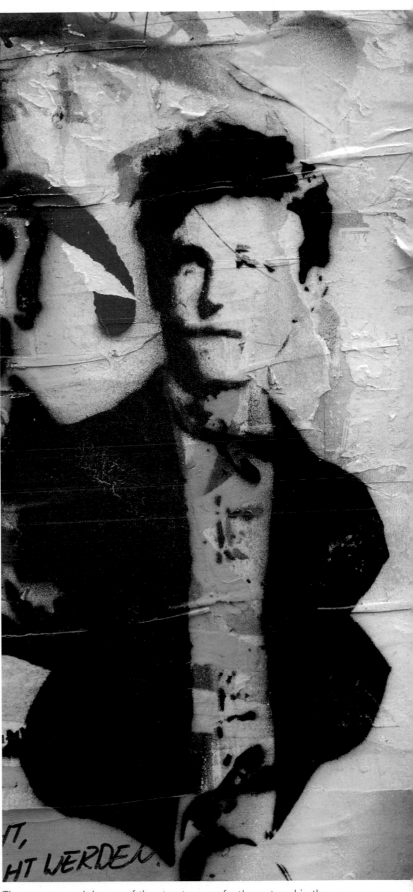

Paris, France: Edith Piaf encapsulated in the trademark drip by EMA in the 20th arrondissement of the city where the singer grew up.

The romance and danger of the street are perfectly captured in the placement of this Zilda & Pedro stencil depicting Arthur Rimbaud, a French poet who travelled throughout Europe mainly on foot.

The auto-rickshaw is an established mode of transport in countries from East Africa to Equador, currently in the form of the Japanese Daihatsu Midget and the Italian Piaggio Ape C. In cities with chaotic traffic, such as Bangkok and New Delhi, this three-wheeled vehicle that topples regularly and offers little protection in a road crash is a familiar sight. This elegiac mural by an uncredited artist in India's capital marks the spiritual journey of passenger and driver.

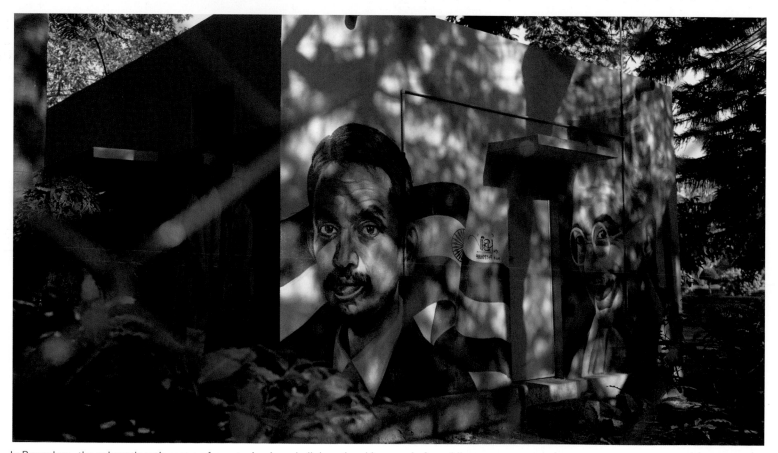

In Bangalore, the subcontinent's centre of new technology, India's national heroes vie for public space.

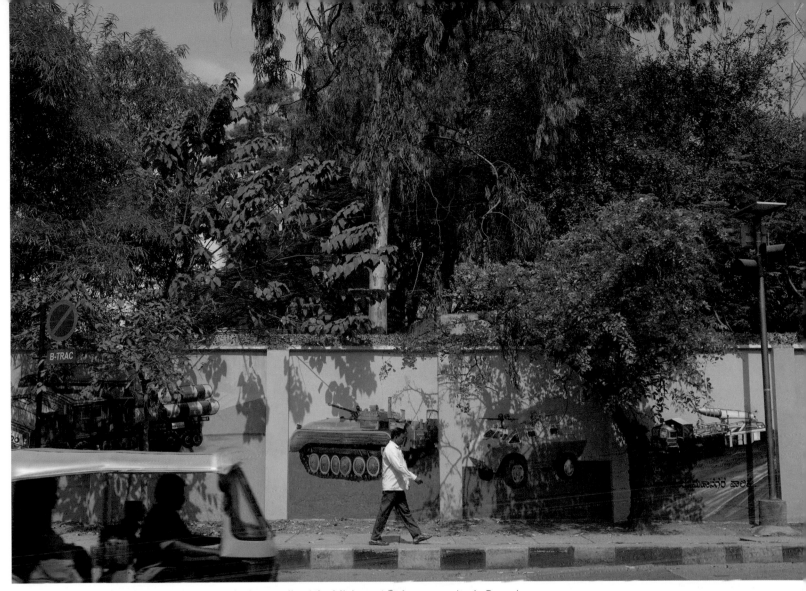

Realistic paintings of modern weapons cover the long walls of the Ministry of Defence complex in Bangalore.

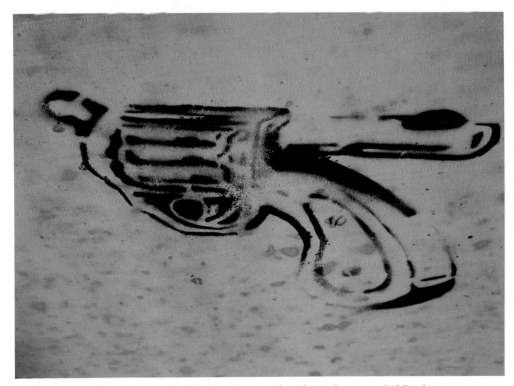

On Spain's Atlantic coast, a gun has the barrel reversed to aim at the person holding it.

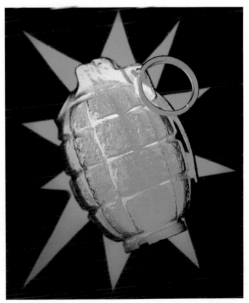

New York-born photographic artist Harry Urgent creates 'negative' images of weapons of war that he plasters around contested locations. His exploding grenade icon has become a common sight from Northern Ireland to Cambodia.

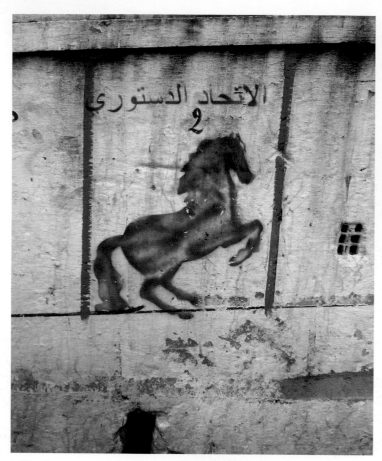

In Tangier, a cosmopolis that has hosted international summits on world affairs, logos of political parties are seen at the entrance to its kasbah.

In London's East End, sporting hero and poet Muhammed Ali is preserved in his prime within a deconstructed Stars and Stripes that belies his anti-Vietnam War beliefs.

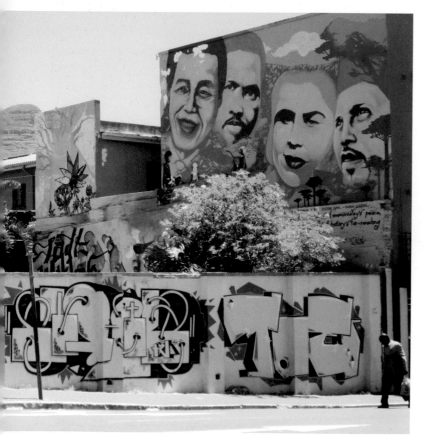

CIVIL RIGHTS

South African civil rights campaigners faced constant danger during the apartheid era, when many of them were imprisoned, tortured and killed. Mak1one's tribute to four of these icons of the political struggle spans a gable end in Cape Town's formerly cosmopolitan District Six, an area synonymous with the forced removal of black residents in the late 1960s. Another figure holds an open book, a symbol encouraging educated people to contribute to the betterment of the country. A message of hope reads, 'These are the realms of immortality's peace, written on the walls of history's far-reaching sons and daughters.' Khalid Shamis, grandson of apartheid activist Imam Haron, commissioned this mural in 2003 and it featured in the acclaimed documentary *The Imam and I*.

Anti-apartheid activists Nelson Mandela, Steve Biko, Zainunnisa 'Cissie' Goole (known as the 'Jewel of District Six') and Imam Haron (left to right) feature on a mural by Mak1one in Cape Town's District Six.
Photo: Sheridan Orr

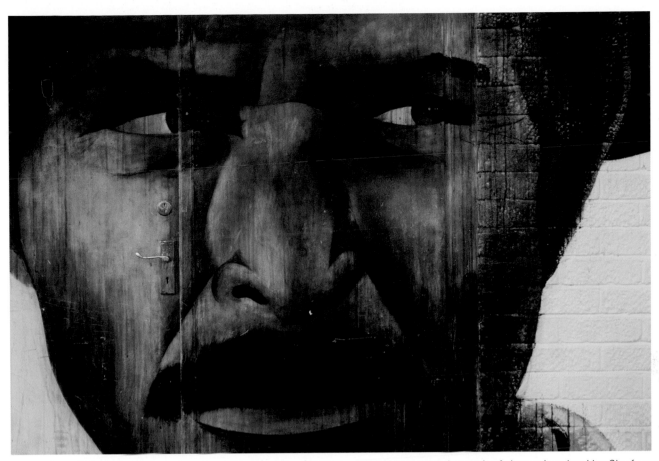

Above: Just off the main north-east road out of London, Ben Slow's engaging close-cropped portrait of cinema icon Lee Van Cleef spreads across a door and a wall. This photo-realist style is expertly produced in a classic cinematic monochrome. Above right: Ben Slow's tag appears to be a sharp-angled cryptogram unless viewed at 90 degrees clockwise.

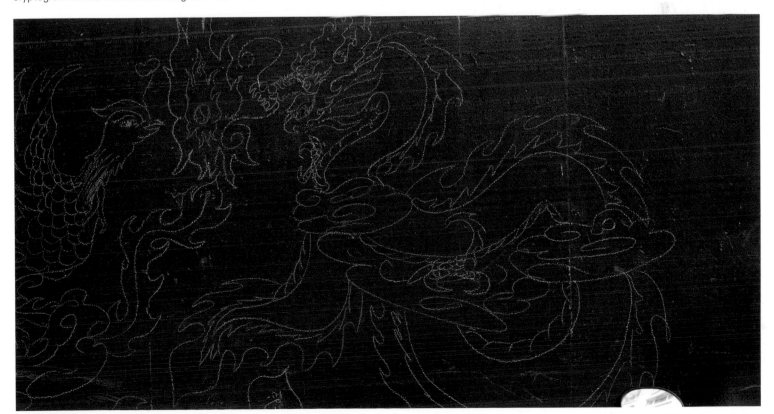

In Ho Chi Minh City, a delicately chalked phoenix battles with a dragon on a bus shelter outside the Rex Hotel. In East Asia, dragon and phoenix symbols are thought to give young married couples good luck in their future together, the phoenix representing the woman and the dragon the man.

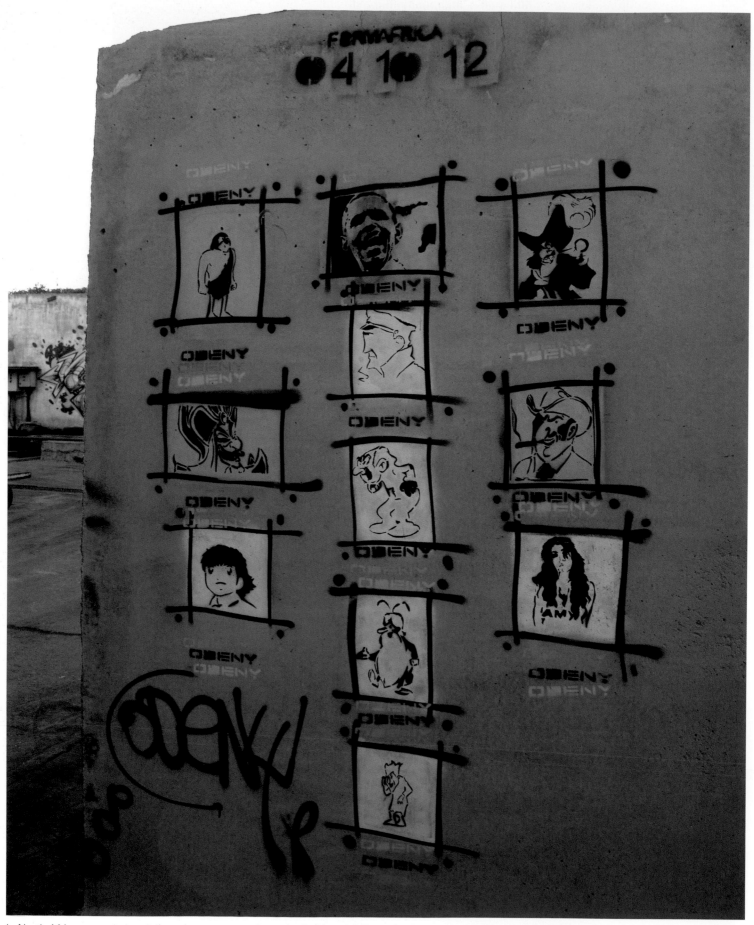

In North Africa, savvy industrialists give space to artists who find it too difficult to work on the streets, providing them with concrete slabs on which they can practise. Odeny mixes Obama with mythical cartoon icons that are steeped in the storytelling traditions of the Arab world.

Casablanca: on a breezeblock wall, Emi Lla creates a character reminiscent of the *Tales of 1001 Nights* who levitates within a nebulous dreamscape, harking back to a pre-colonial past without border restrictions.

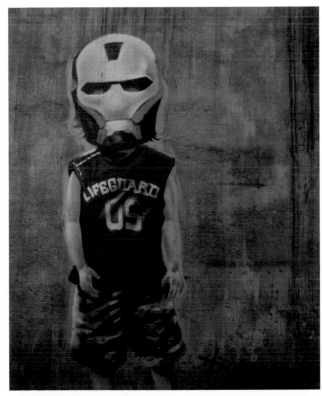

Marron takes the Korean cyborg hero Iron Kid and transposes him onto the wall of a forge in Casablanca, suggesting that the robot boy of this TV series could be wrought in reality, a man-machine who preserves life.

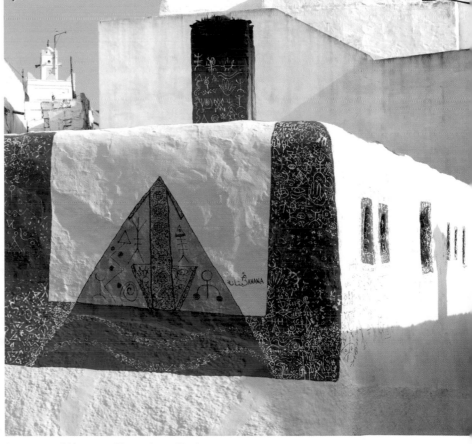

Azemmour, Morocco Photo: Anne Heslop

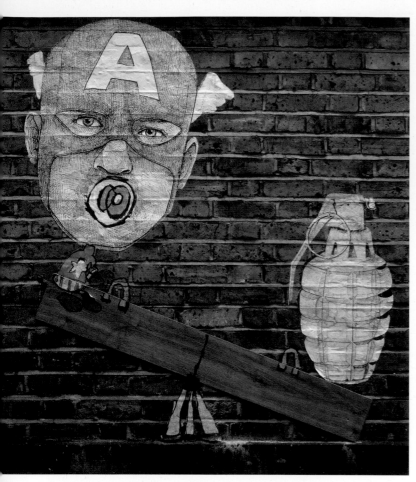

Captain America Blockhead by HIN

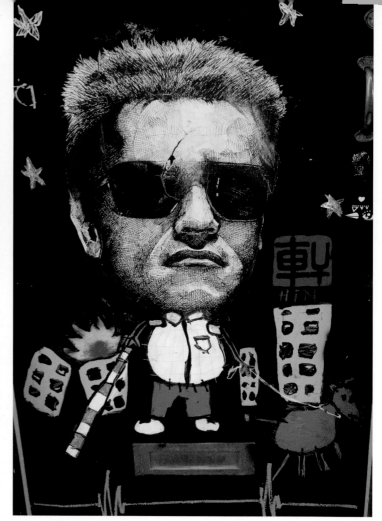

Arnie Blockhead by HIN

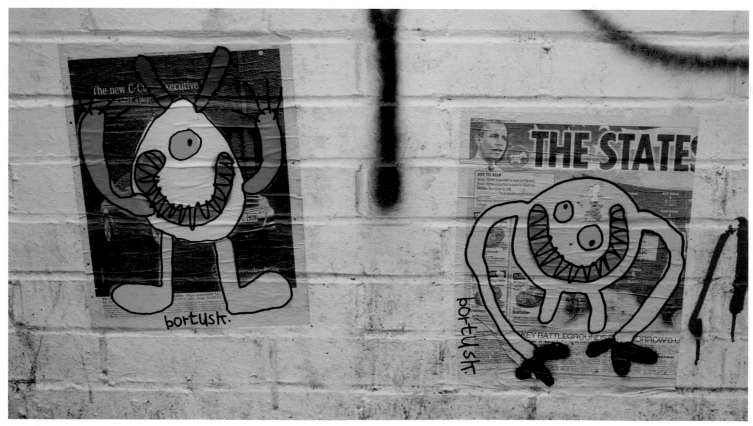

Bortusk delves deep into the imagination, producing curiously disproportioned alien figures that occupy news pages,
pasted up like directives along popular public walkways such as here on the towpath of Regent's Canal in London.

Hong Kong-born HIN draws on the disciplines at either extreme of the artistic spectrum — Japanese manga and traditional Chinese watercolours. HIN's Blockhead series features out-of-proportion figures that borrow from the popular escapist staples of Hollywood and Marvel, rendered absurd by being framed in comic dystopias.

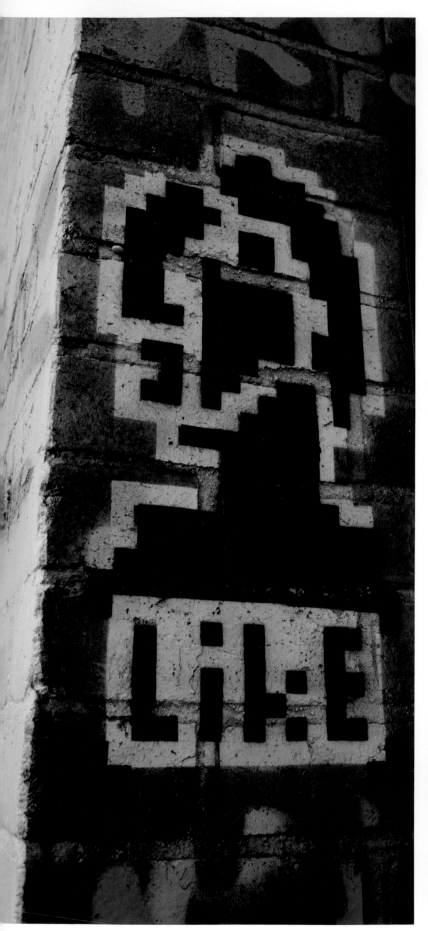

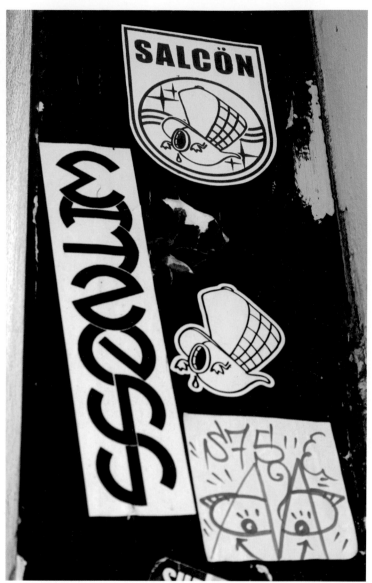

In Paris, sticker artist Salcön takes corporate logos such as the classic Philips Electronics stars and radiowaves and turns them into effective motifs for the presentation of new ideas and messages.

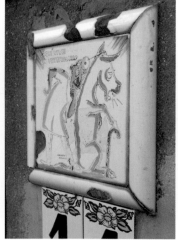

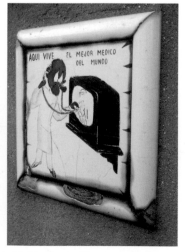

London: a rendering of the 'like' option symbol in social media stresses the notion of individual choice and of making that choice public.

Veterinarian (left) and doctor's notices in Tarifa, Spain. The doctor's sign reads: 'The best doctor in the world lives here.'

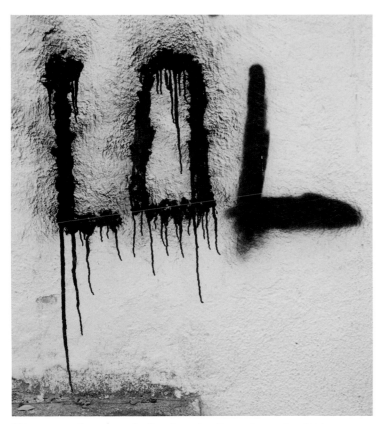

This text-speak acronym for 'laugh out loud' was famously mistaken to mean 'lots of love' by British Prime Minister David Cameron, an error revealed during an investigation into phone-hacking by tabloid journalists in the UK. This art is in Seville, Spain.

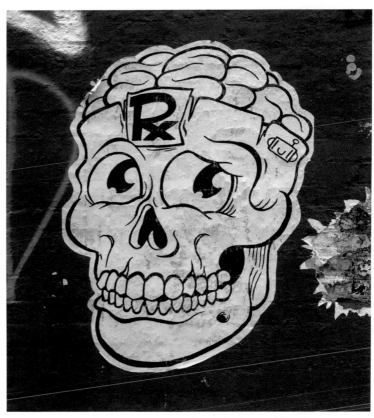

Here an artist plays with the chemist's Rx shorthand. Pharmacists hang Rx signs outside their stores, so that patients know where to get their doctor's prescriptions translated into medicines. This skull is in Paris.

Code FC places camera icons in inner city areas under surveillance in London, the city with the most CCTV cameras in the world.

The outline of a car denotes the location of a repair garage on the Andalusian coast, Spain.

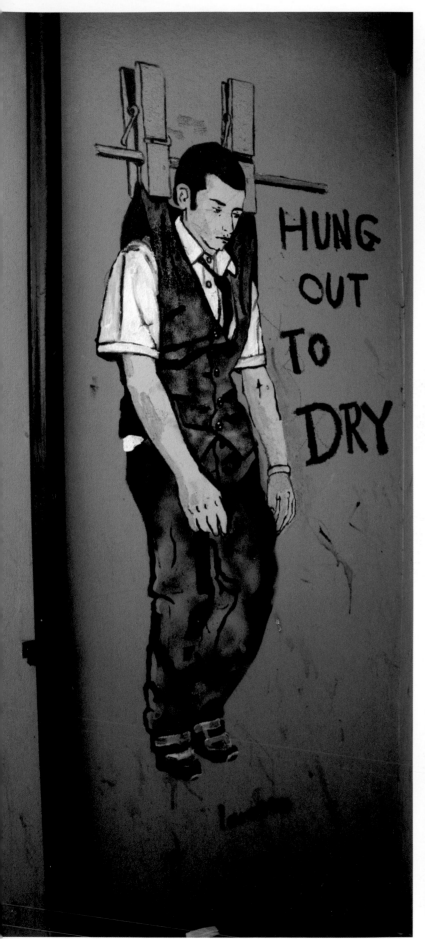

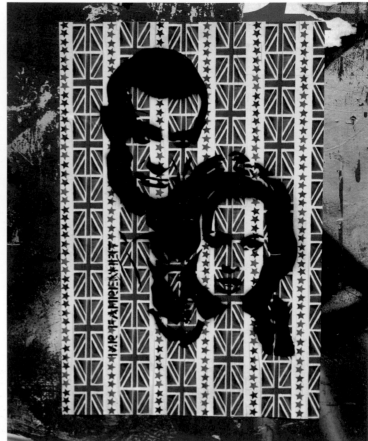

Mr Fahrenheit, London

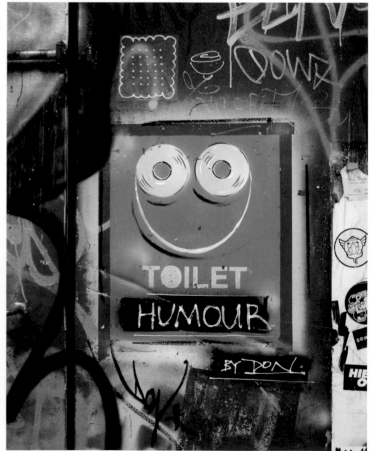

Loretto, London

DON, London

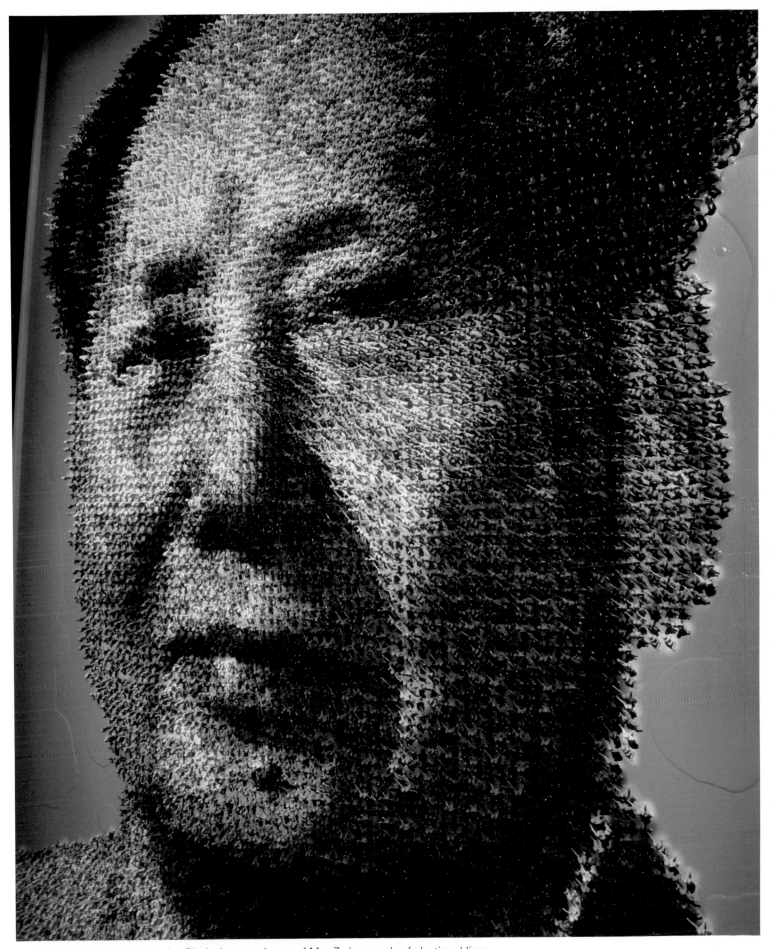

Workers of the World Unite by Joe Black shows an image of Mao Zedong made of plastic soldiers.

Blek Le Rat, London

Unknown artist, London; this image obscures a detailed wheatpaste by Swoon.

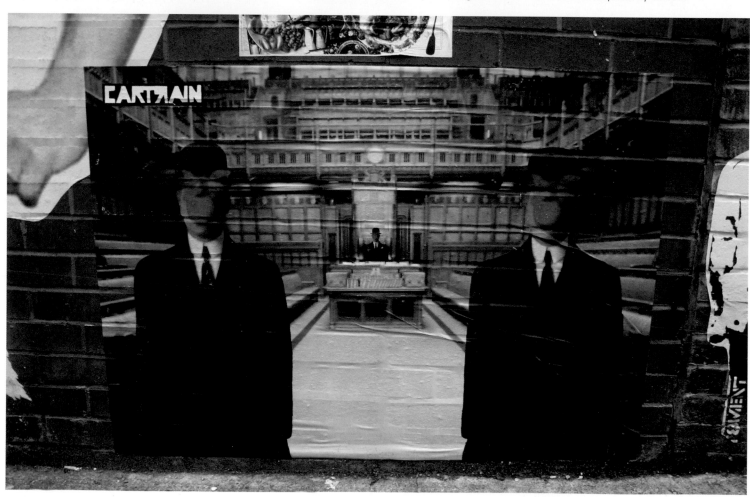

Cartrain appropriates Magritte icons, London.

Above: superheroes by Best, London. Below: a homage to French illustrator Moebius by Jim Rockwell aka Probs, London

The peace symbol undulates over shutter rollers in a Paris suburb.

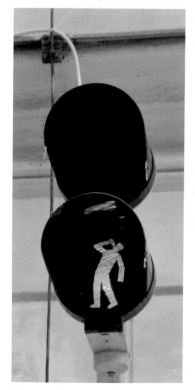

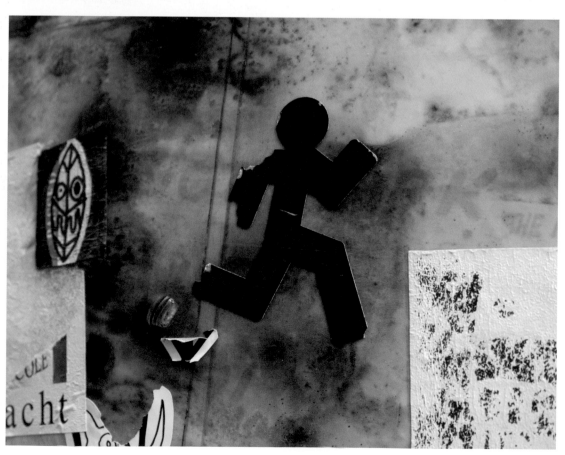

Above and right: traffic-crossing figures are adjusted or removed to other settings. Photos: Abbe Atkin

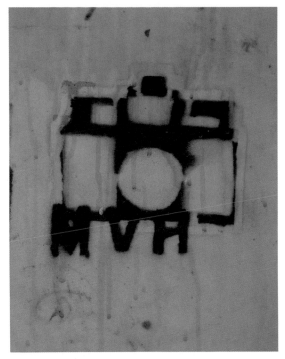

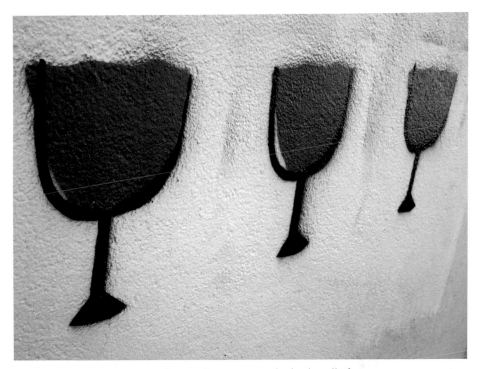

In Barcelona, a classic camera design by MVH lurks in a doorway.

These simple representations of wine glasses are on the back wall of a supermarket in Nîmes, a centre of viticulture in the south of France.

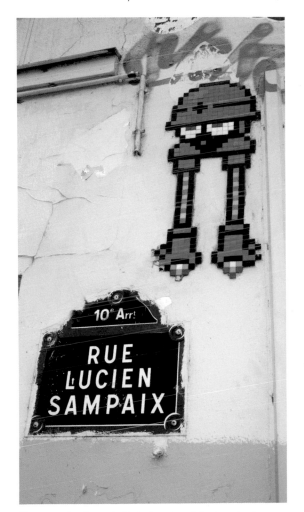

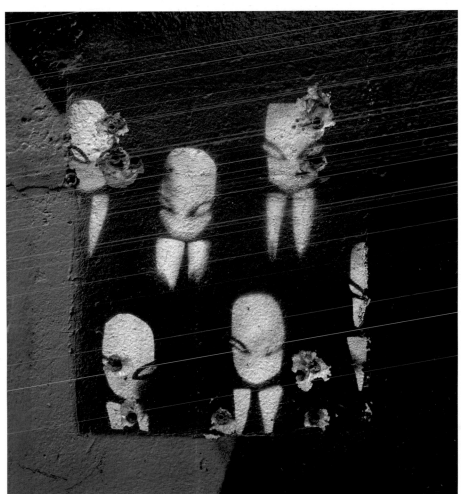

The use of enlarged pixels in artwork by Invader has developed into both figurative and abstract forms, as on this unsigned piece near Gare de l'Est in Paris.

Also in Paris, corporate aliens in formal suits grace a wall.

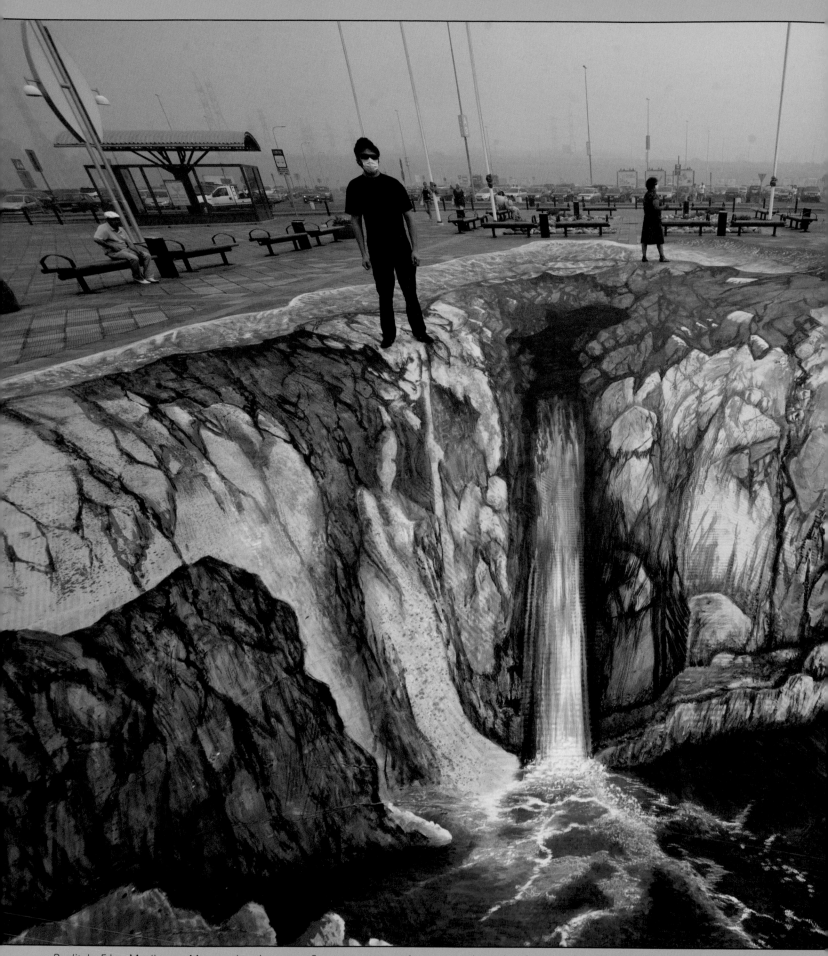

Duality by Edgar Mueller at a Moscow shopping centre. Spectators wear masks to protect themselves from peat fires that were burning in the area at the time.

ILLUSIONS

Illusion is a major element of urban art. Where smoke and mirrors are the tools of the cabaret magician, abstract angles and realist interventions are the tricks which artists exploit to lure the viewer into examining the content of their work and figuring out what is real and what is not.

Psycho scene by Mr Fahrenheit, London

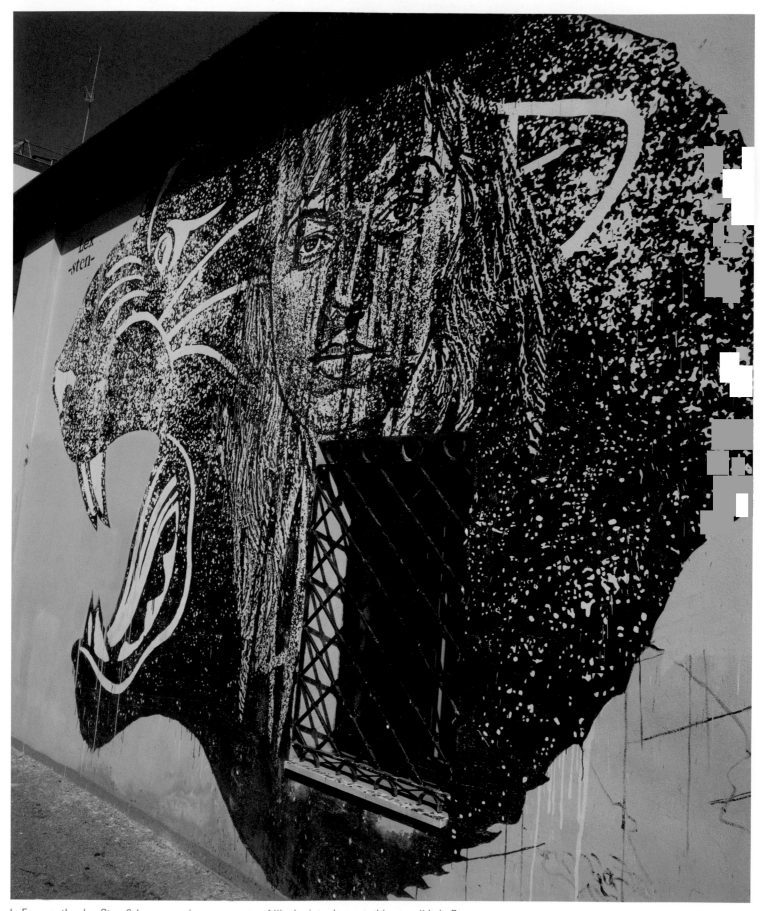

In Europe, the duo Sten & Lex are major proponents of illusionist urban art; this stencil is in Rome.

he London-based German group St8ment take their name from the vernacular of compressed text-speak. They specialize in portraits made from oversized pixels. Upon close inspection, their almost life-size figures are shown to be deliberately blurred.

Pixellated art by St8ment, London, references cameraphone images which are not of sufficiently high quality to be used in print.

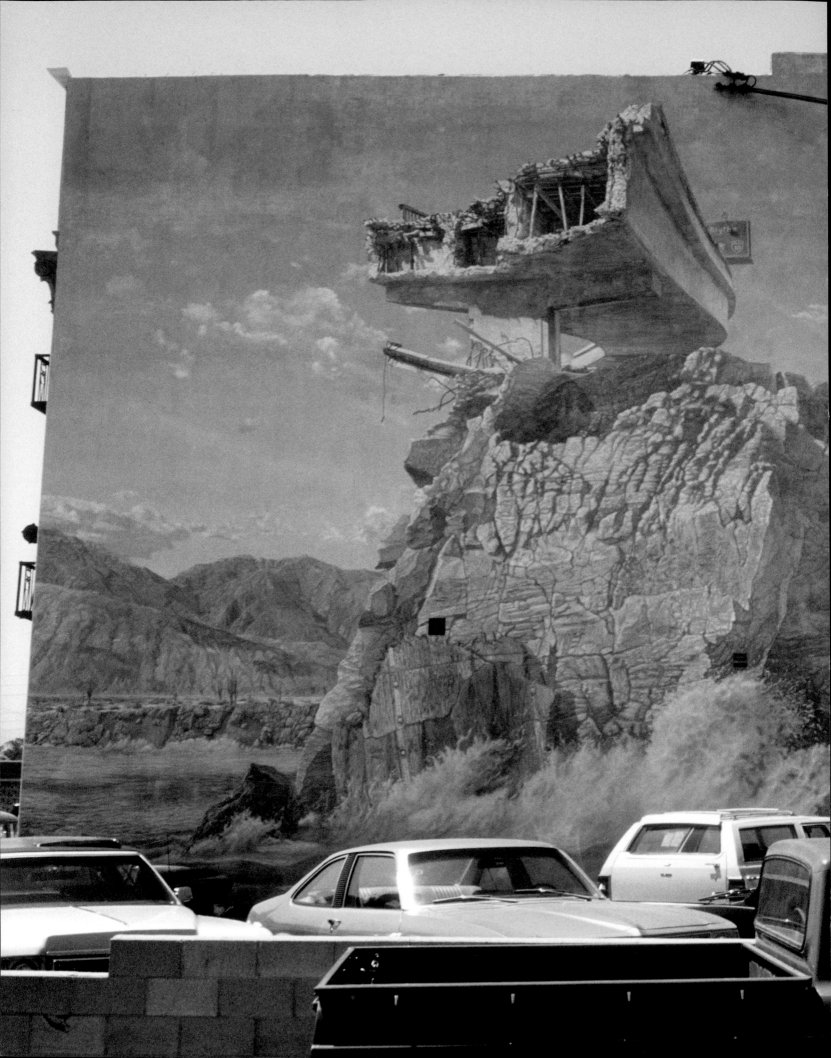

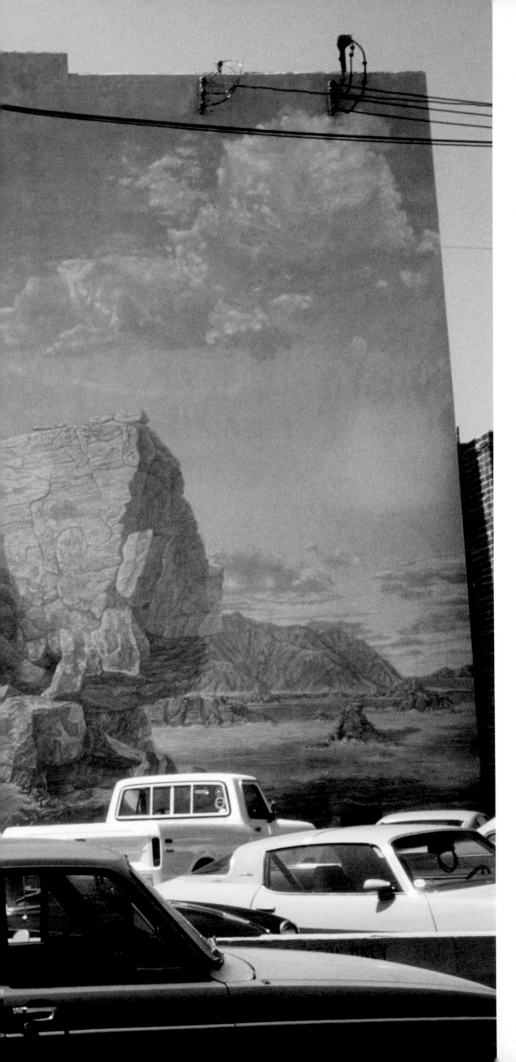

GRAND VISIONS

At the opposite end of the scale to stencil and portrait art, huge murals using forced perspective with its roots in architecture make objects appear larger and closer or smaller and further away than they are in reality.

During the 1970s optical trickery was employed on a grand scale around Santa Monica and Venice Beach on the Pacific coast of southern California, as the LA Fine Art Squad made *trompe l'œil* frescoes that baked in the searing heat. The LA Fine Art Squad, a quartet of grand visionaries named James Frazin, Victor Henderson, Leonard Koren and Terry Schoonhoven, operated only between 1969 and 1974 and they reportedly did not care if their works were perceived as temporary. Their most ambitious piece, still intact but now very faded, offers a portal of fantasy in the metropolitan sprawl of Los Angeles. *Isle of California*, created in 1970–72 and photographed here in 1978, shows a disembodied freeway overpass, sliced off above a roaring surf, beneath a Baroque cloudscape worthy of Venetian master Giambattista Tiepolo. This is a psychological illusion as well as a physical one. The French phrase *trompe l'œil* directly translates as 'deceive the eye', describing a technique of producing realistic imagery that appears three-dimensional.

Photo: Peter Mackertich

Large geometric pieces occupying whole roads have come back into fashion. These are inspired by the tradition of chalk-drawn reproductions of famous paintings that art students would reproduce outside major galleries, hoping to raise funds from passing art aficionados. Edgar Mueller is a leading exponent of this revival, using the latest image-making technologies to render surrealistic visions with site-specific interventions on the street. He has refined an amazing ability to trick the eyes of passersby into seeing three-dimensional scenes and objects on completely flat tarmac. His work is created using a projection known as anamorphosis.

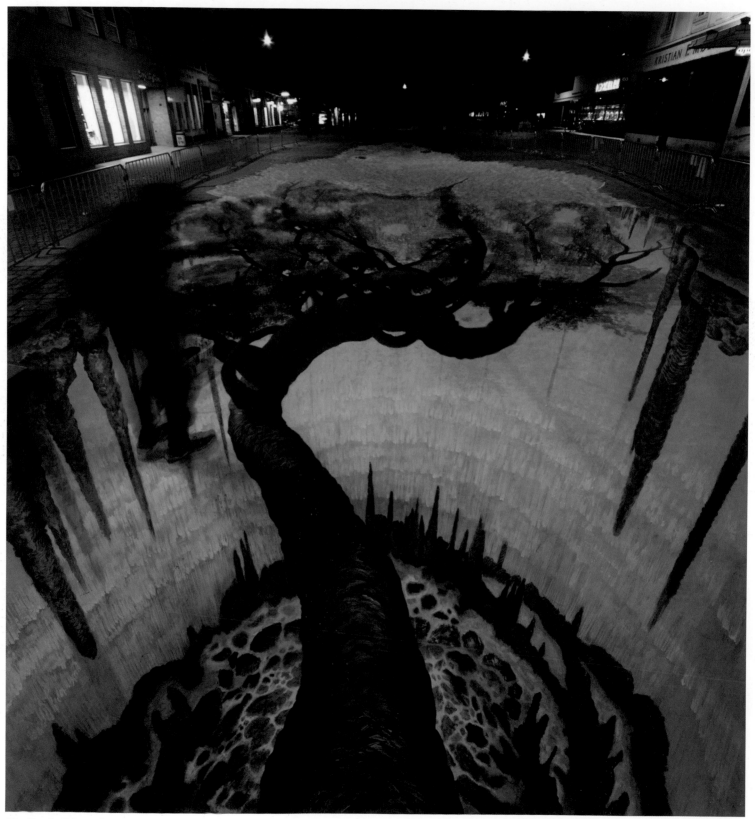

The Tree by Edgar Mueller, Germany

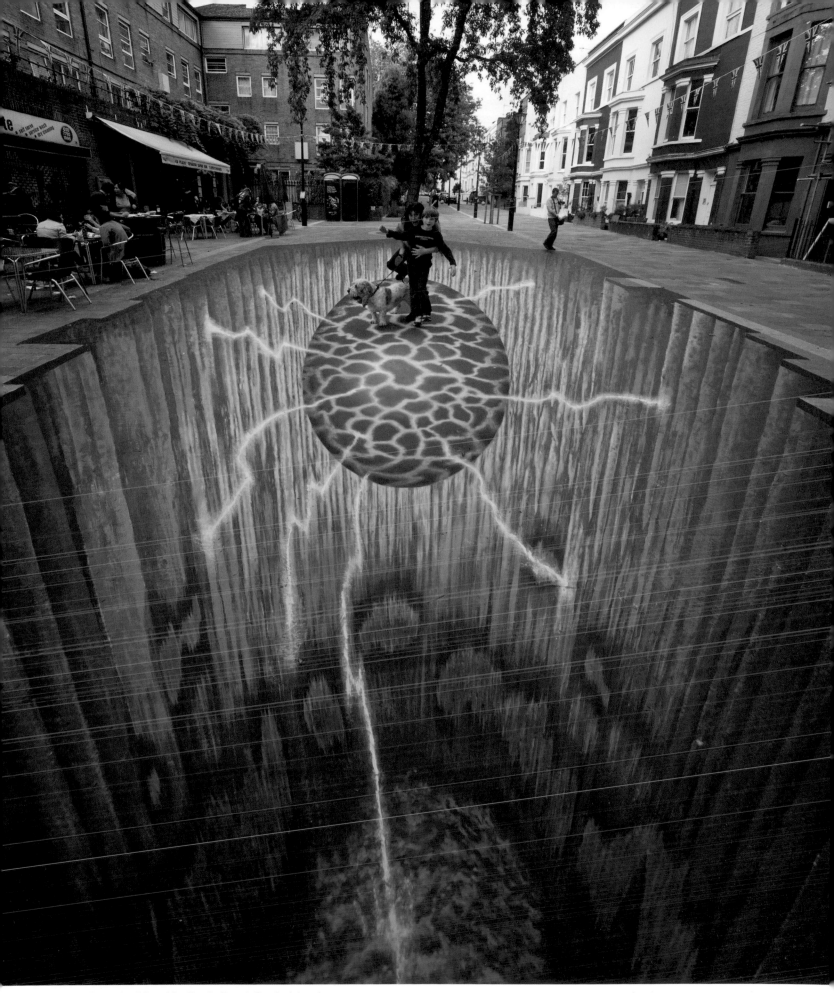

Evolution–Energy by Edgar Mueller, In Transit Festival, London

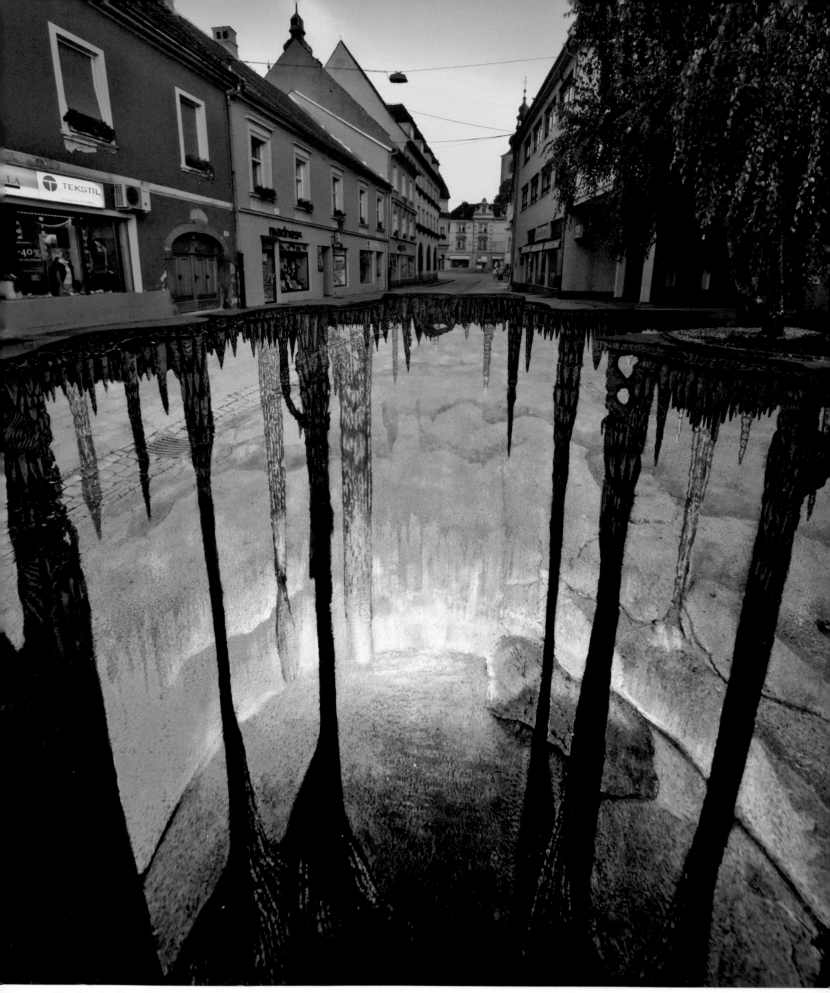

The Cave by Edgar Mueller, Slovenia

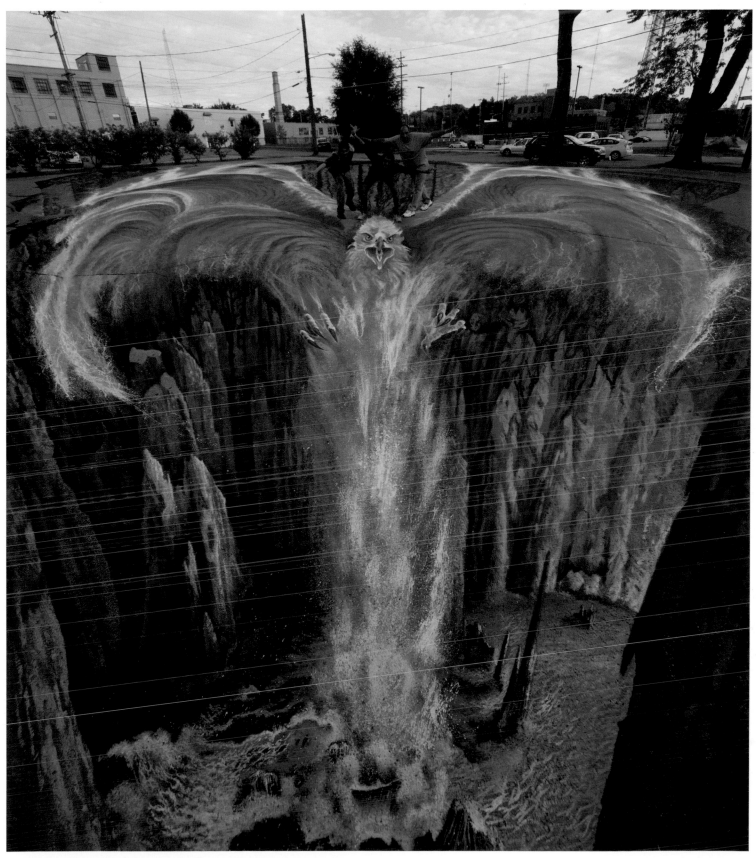

Transformation from the Unconditional Love series, Edgar Mueller, USA

ROADSWORTH

Outstanding practitioners still surprise with their originality, as can be seen with Montreal-based Roadsworth. One of his hosts in the USA, the Southeastern Center for Contemporary Art (SECCA), managed to have some streets officially blocked while he worked. However, for *Conveyor Belt* (opposite) Roadsworth dodged traffic as he laid down go-faster cogs on a pedestrian crossing. Resembling a moving walkway, this intervention comments on an increasingly sedentary populace, maybe even encouraging a brisker pace as people cross the street.

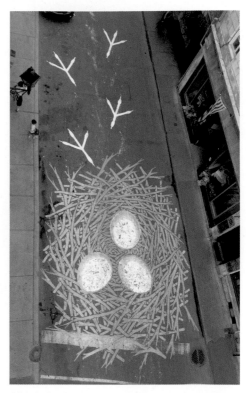

Nid de Poule: the comedic illusion of a massive bird's nest in the middle of the road emphasizes the fragility of life.

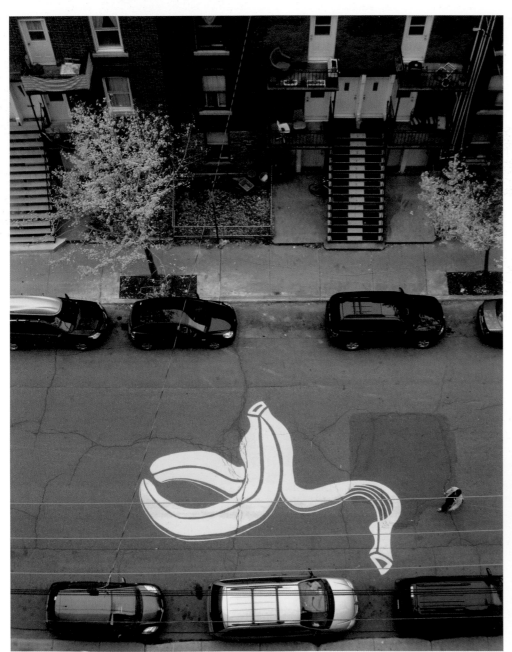

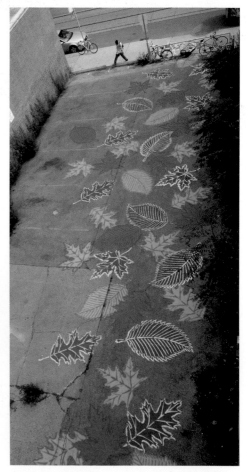

Peeled Pop: on this Montreal street, Roadsworth empowers pedestrians by employing a giant banana skin to warn of careless drivers. Photos on this page: Peter Gibson

Fall Leaves, Toronto

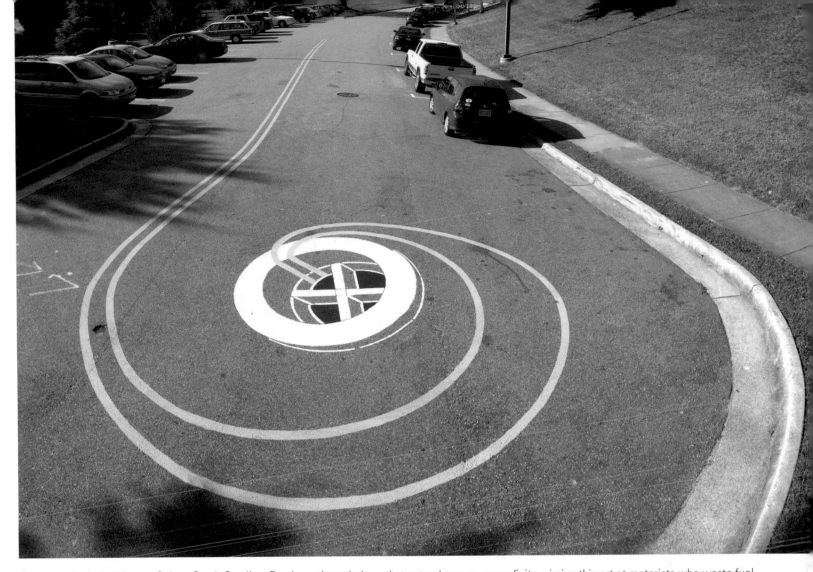

Down the Drain: in Winston-Salem, South Carolina, Roadsworth reminds us that natural resources are finite, aiming this art at motorists who waste fuel on ill-planned journeys. Roadsworth reclaims public spaces by adding oversized elements to satirize our worship of the car.　Photo: Cliff Dossel/SECCA

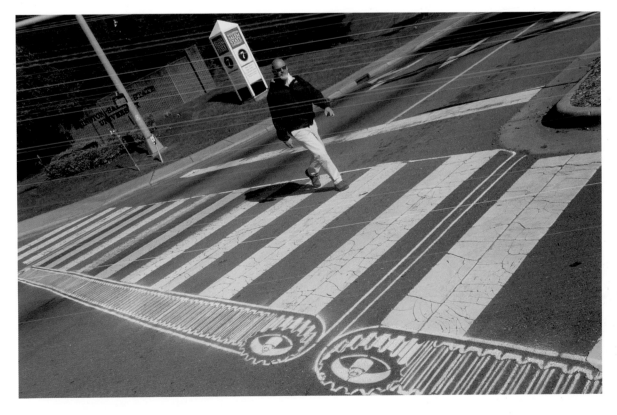

Conveyor Belt for Inside/Out:
Artists in the Community II
public art programme
Photo: Peter Gibson

EUROPEAN MURALS

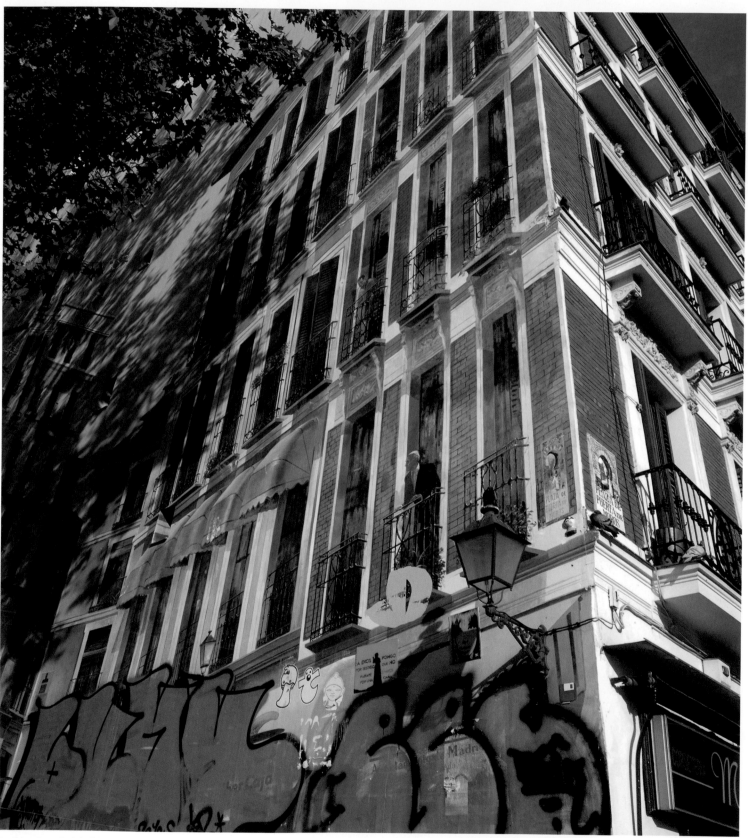

In this piece in Madrid, the real balconied façade is mimicked by a wall that has attracted tags and paste-ups at street level.

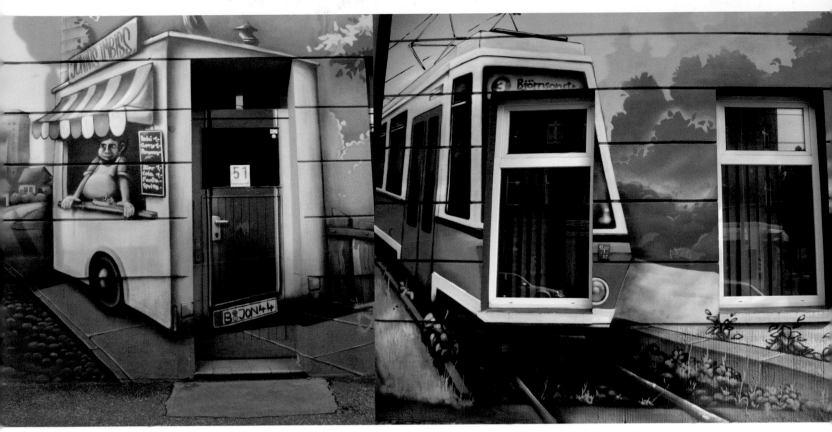

On Goethestrasse in Berlin, existing windows are part of a design that stretches around corners and reveals imagined interiors.

In Dijon, two- and three-dimensional illusion and reality blend mural, bust and shutters. Photos: Doralba Picerno

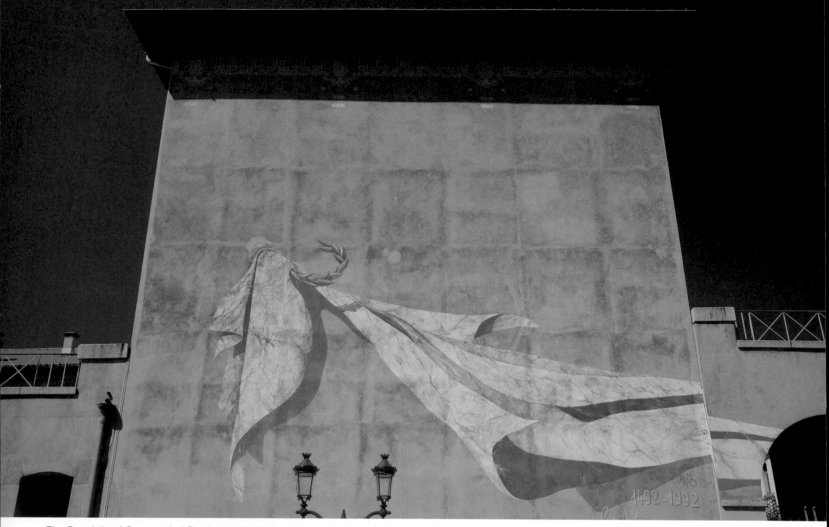

The Republic of Genoa ruled Corsica until 1755 and many Corsicans believe that Christopher Columbus was born on their island rather than in Genoa itself. In 1993, urban artist Maximo painted a flowing white flag across a government building in the Corsican capital, Ajaccio, to celebrate the 500th anniversary of Columbus's discovery of the Americas.

A hollowed-out rock on the Corsican corniche captures the unmistakable outline of the island's most famous son, Napoleon Bonaparte.

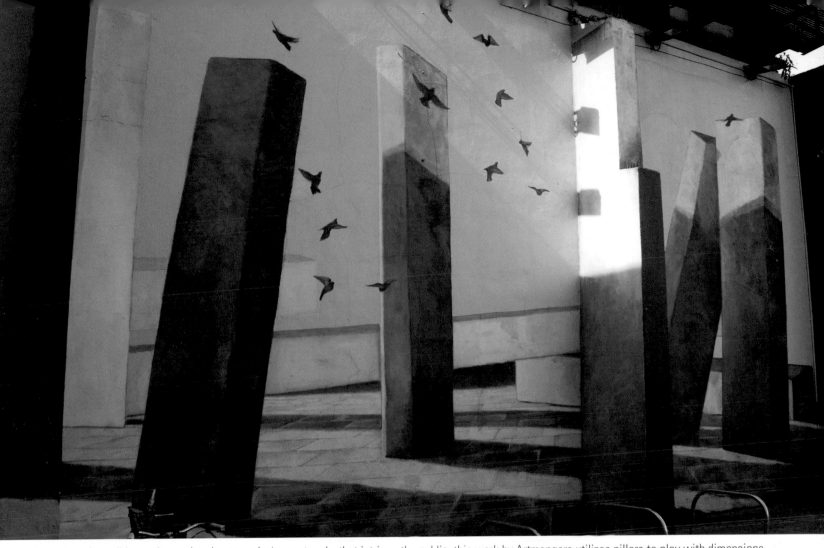

Lewisham Council in south-east London commissions artworks that intrigue the public; this work by Artmongers utilizes pillars to play with dimensions.

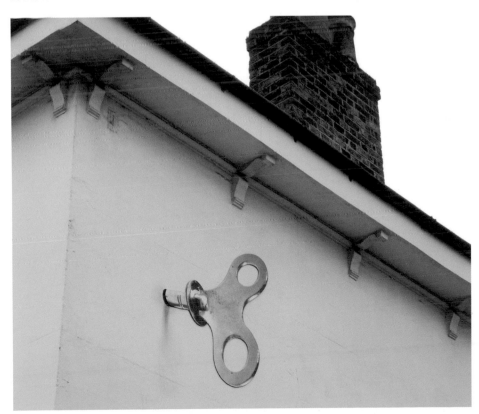

Again in Lewisham, this beautifully rendered simple clockwork key by Artmongers appears convincingly three-dimensional until looked at very closely.

On the Truman Brewery in east London, the facial characteristics of a sculpted relief by Vhils become salient in the soft afternoon light.

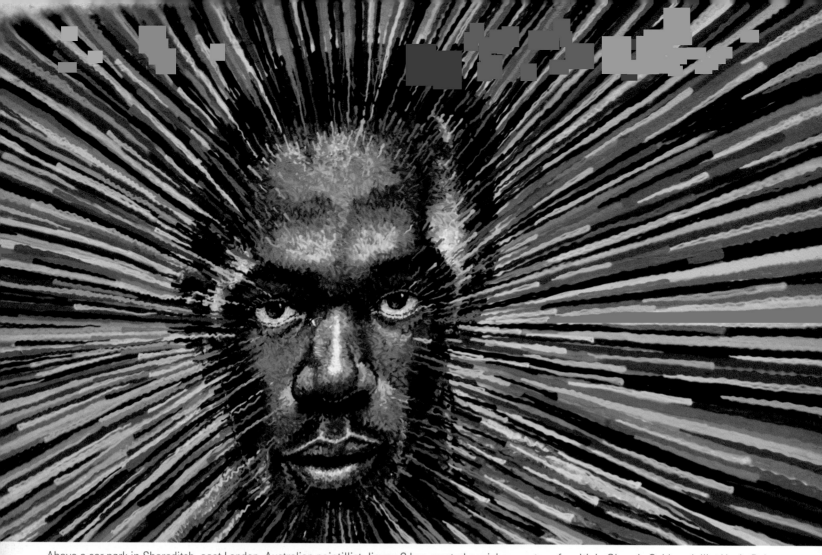

Above a car park in Shoreditch, east London, Australian pointillist Jimmy C has created a rainbow vortex of multiple Olympic Gold medallist Usain Bolt.

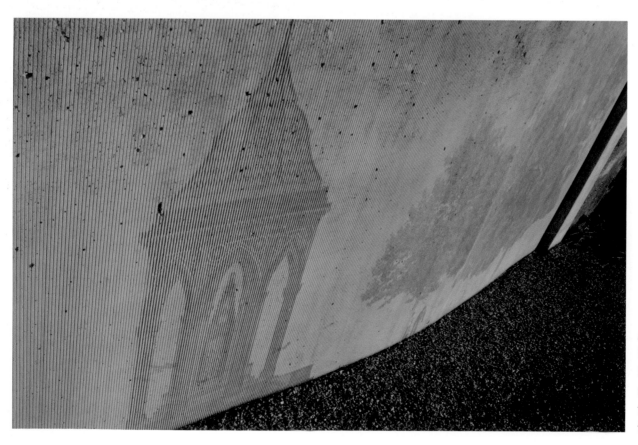

A series of lines in concrete in east London's Victoria Park reveals a tower and trees when observed from the side.

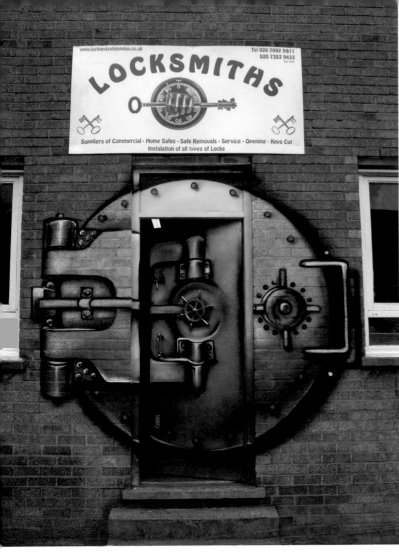

Also in London, a locksmith presents a clever comment on security. During opening hours, the door to this vault is left enticingly ajar.

Unknown artist, Cadiz

Mentalgassi applied his work *SUBWAY: Bruce Davidson (SIDE 1)* to a fence in a form that renders it visible when seen from an acute angle. Here it is backlit through a slatted gobo at Opera Gallery's Urban Masters show in Shoreditch, east London.

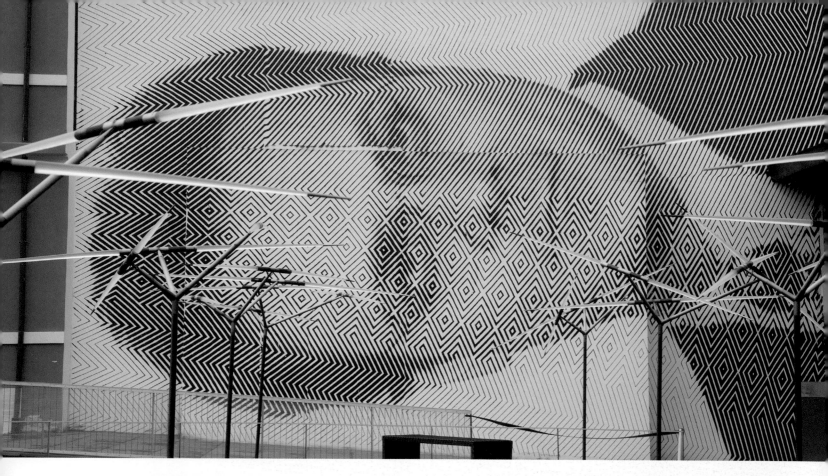

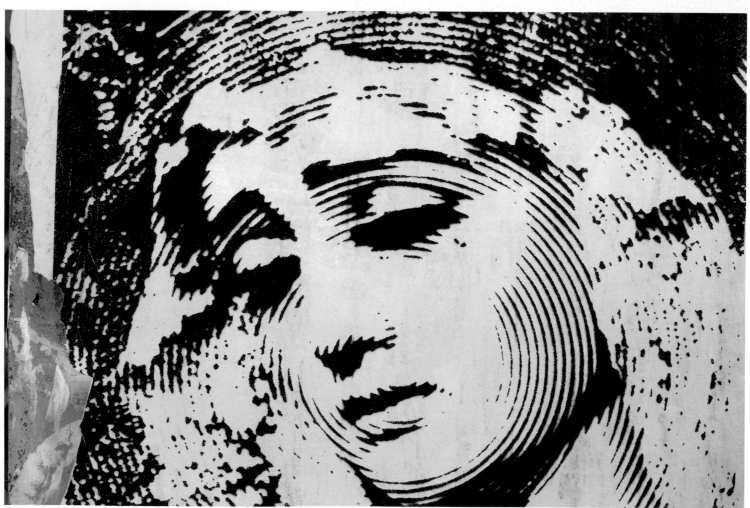

In Provence, France, a simple vertiginous pattern reveals what appears to be Joan of Arc.

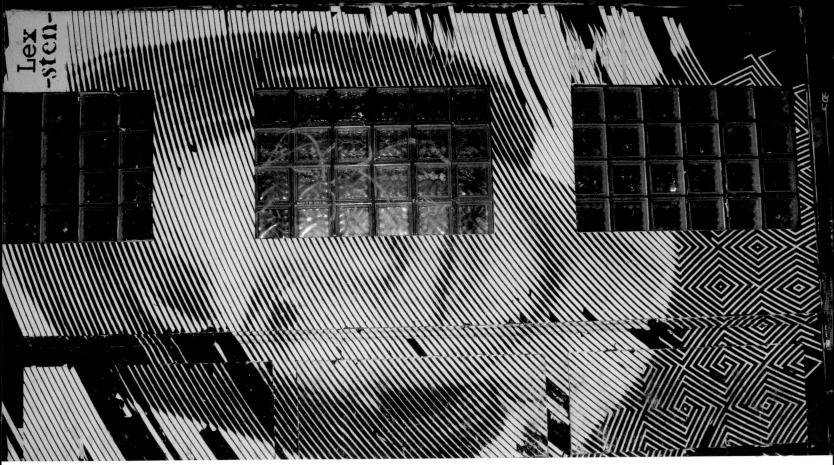

Opposite and above: Sten & Lex use a method of preparation that allows the removal of paper strips on site to gradually reveal black-and-white portraits that often go unnoticed until a certain viewpoint is reached.

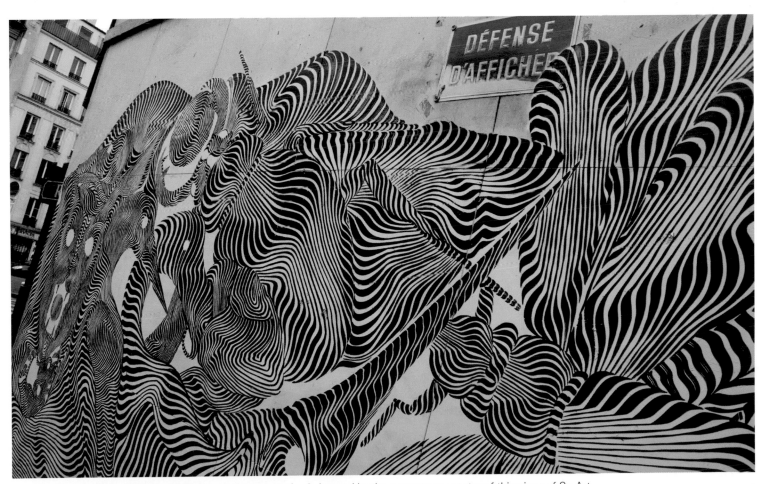

In Paris, the ubiquitous *défense d'afficher* public order notice is ignored by the anonymous creator of this piece of Op Art.

VISUAL CONCEITS

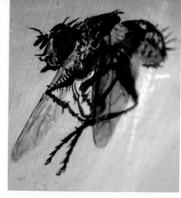

Urban art is inspired by both modern and classical art, yet it is also driven by the desire to challenge perceptions through the unpredictability of positioning and content. Witty and provocative, these largely illegal installations offer humour and intrigue. Sometimes the visual joke is only apparent when the art is viewed from a particular angle, as is the case with the graffiti ghosts that haunt Rome's architectural niches (below).

Under Blackfriars Bridge in south London, a housefly subtly embellishes the tunnel wall.

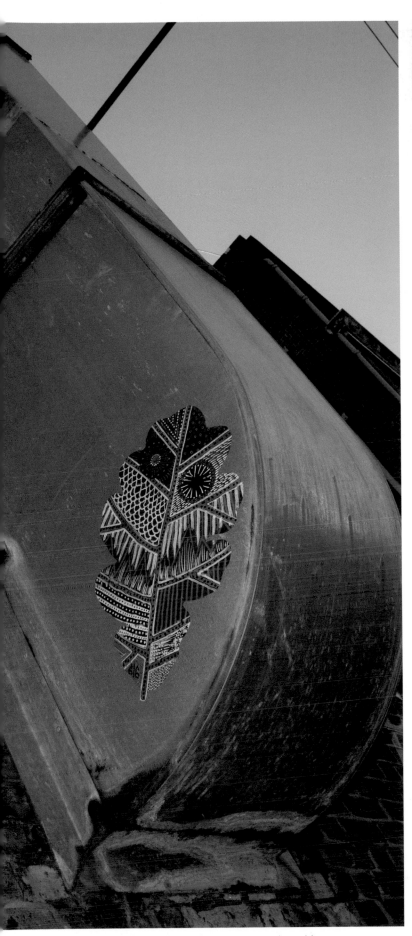

Smaller interventions can be difficult to spot, such as this cutaway pattern by SixOneSix decorating a flue near artists' studios in north-east London.

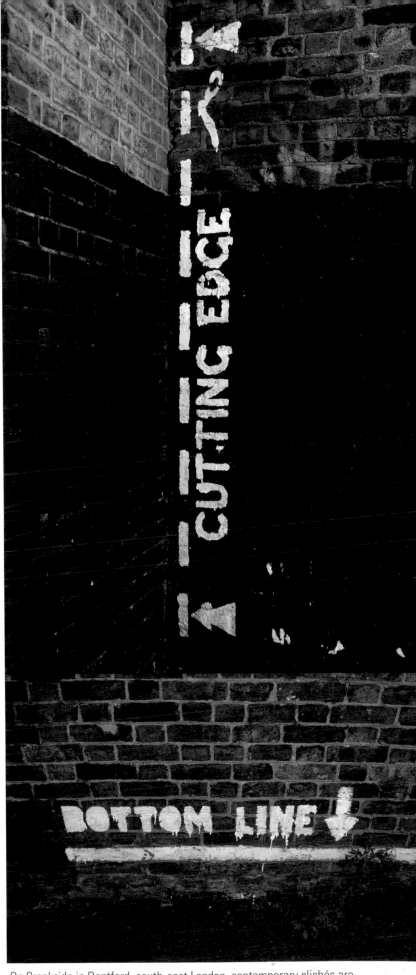

On Creekside in Deptford, south-east London, contemporary clichés are enhanced with graphic wit.

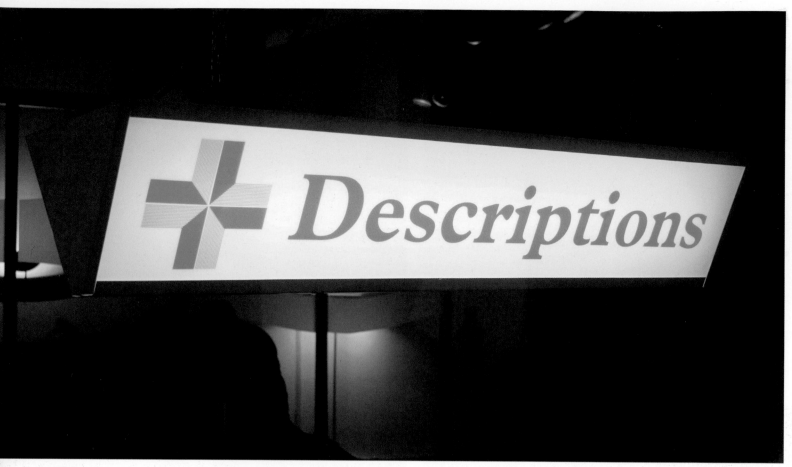

While retaining an appearance of functionality, the language of the street can be subverted, literally illuminating what is read automatically as something else because of its established context. A 'Prescriptions' lightbox installed at a former advertising agency in London's West End was adjusted to read 'Descriptions' by interventionist arts group Fitzrovia Noir (before the venue became the Hanmi Gallery). The Re:Development project gave the illusion of the building having alternative uses, while drawing its inspiration from the legacy of pre-digital commercial art departments.

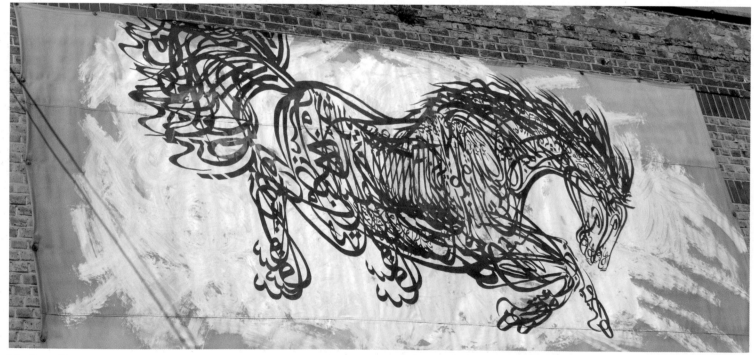

Muslim calligraphers have diversely transposed the dots, lines and curves of Arabic script into intricate patterns, taking advantage of the creative freedom offered by this language when written. Islamic calligraphy is suited to cursive flow, demonstrated here by Fenoon, who forms symbols into the shape of a horse. This art is in London.

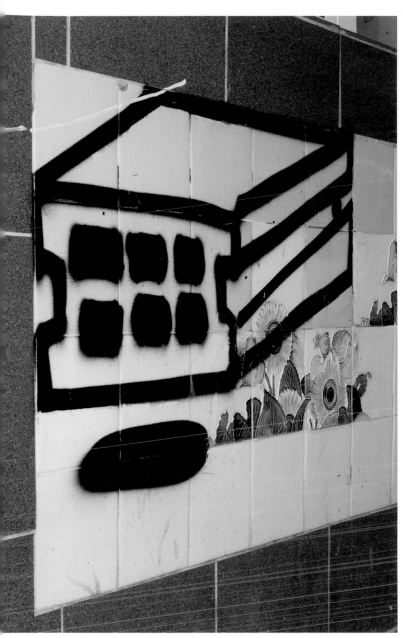

A girder sprayed onto a rural scene on the front of a Parisian house.

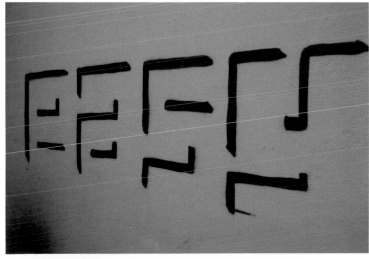

In Casablanca, Easy combines eastern and western symbols in a simple illusion of his name.

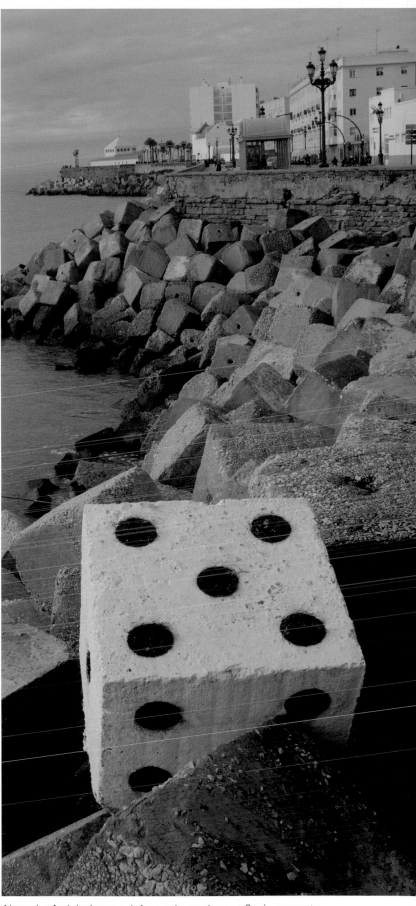

Along the Andalusian sea defences in south-west Spain, concrete blocks lie decorated with stencils, tags and more witty additions, including huge dice.

Sometimes illusions extend beyond the merely visual through their unexpected relationship with the objects they decorate. Here, on street junction boxes in London, coffee is celebrated in a series by Stephen Ball. But is this art or subliminal advertising? Photos: Ellis Leeper

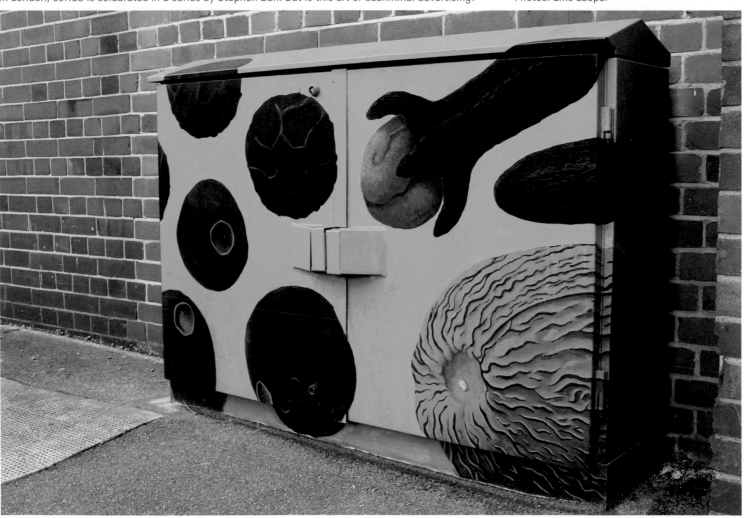

In Prague, a simplistic illusion showing the back of a road sign attracts signifiers from artists about to operate in the immediate area.

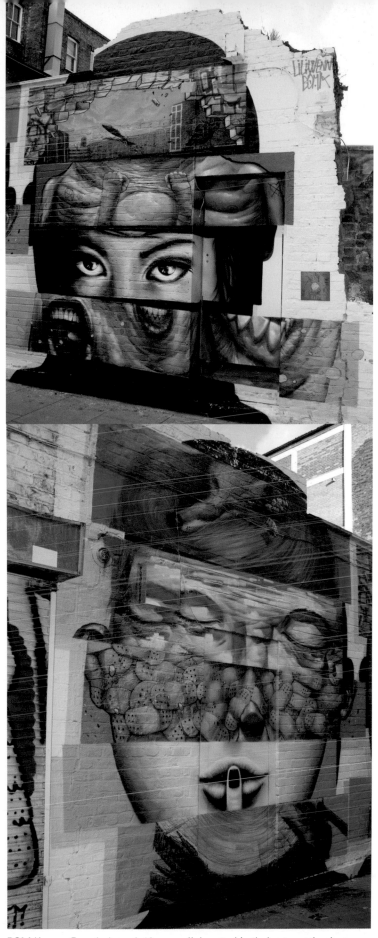

BOM.K are a French duo who have collaborated in their respective home cities of Paris and Brest. Here, in Hanbury Street, London, their disrupted faces blend with Liliwenn's dream-like scenes to produce interchangeable features reminiscent of a photofit.

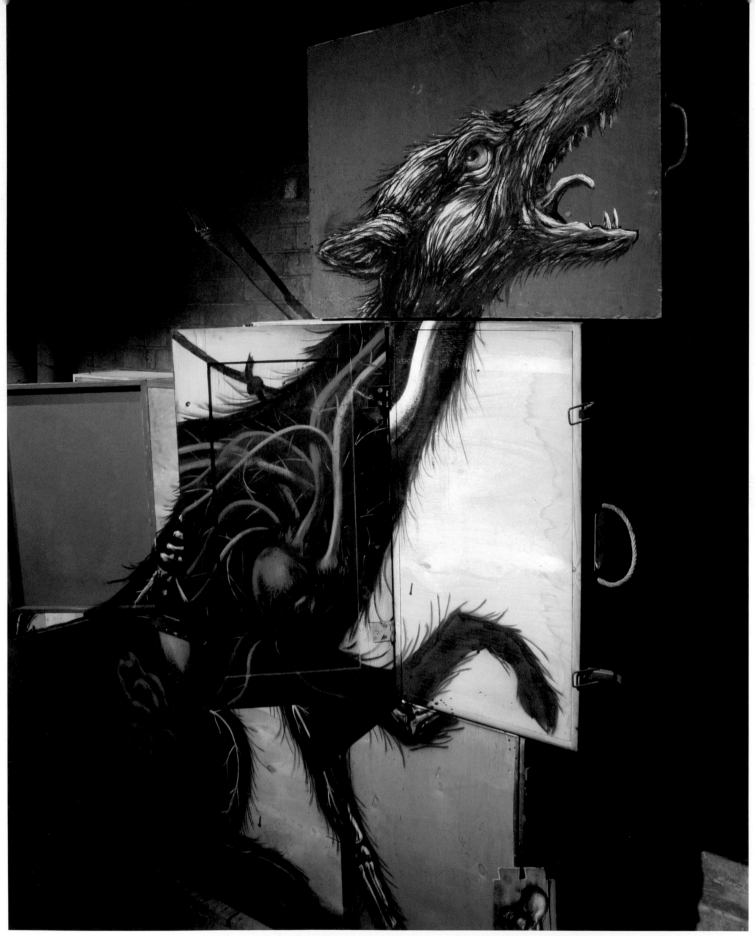

Canis: ROA's forays into three-dimensional representations of animals utilize found boxes morphed into scientific display cases. These show multiple-layered views of his subjects, from surface detail to X-ray style analysis of the animals' anatomy. When doors are angled, organs or bones appear over the biological assemblage, giving many choices about how we perceive parts of a body. With the attention to detail of a forensic pathologist, ROA dissects the life cycle through processes of revelation and decay.

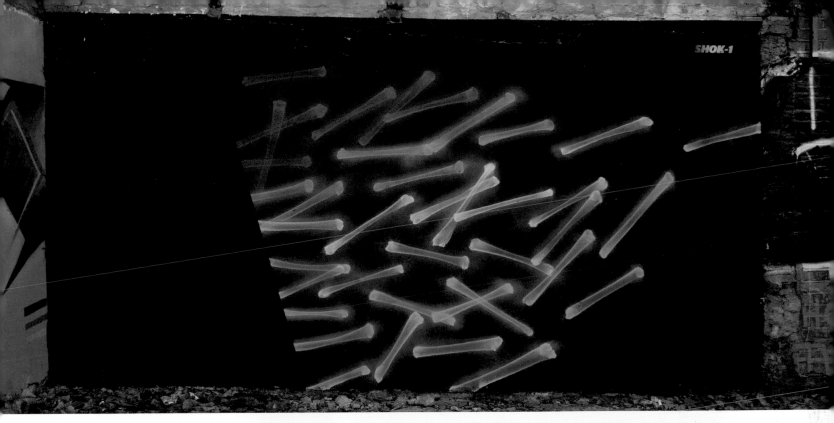

Shok 1 is a leading
exponent of overlaid
paintings inspired by
medical imaging.

Photos: Doralba Picerno

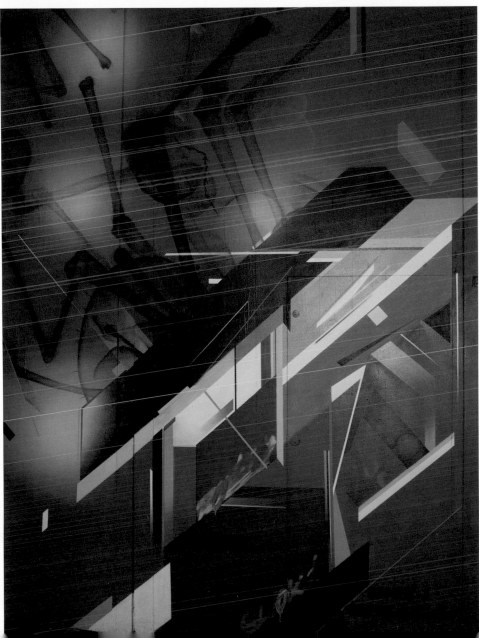

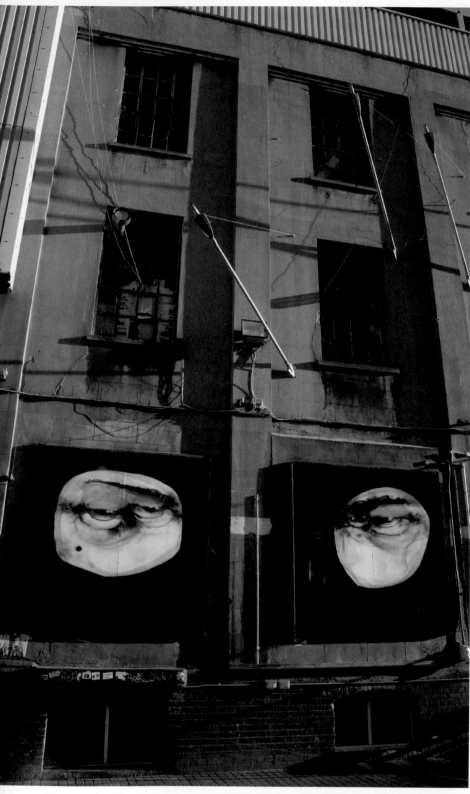

Lister's surreal human eyes are mounted on the back wall of the Truman Brewery in east London, an area at the centre of high-quality street art. Lister's illusion is augmented by an existing installation of projecting steel arrows. This was part of a project mounted during the 2012 Olympic Games, and brings to mind Alexander the Great's use of oversized weapons in battle. The reason for this was to spread the word that his warriors were giants (an early example of subliminal propaganda through illusion). The juxtaposition of sharp metal and eyes references the fragility of human vision and is reminiscent of the infamous opening scene of Luis Buñuel's film *Un Chien Andalou*, where a woman's eyeball is apparently slit with a razor.

David Shillinglaw's illusory visions appear both in the street and in temporary gallery spaces.

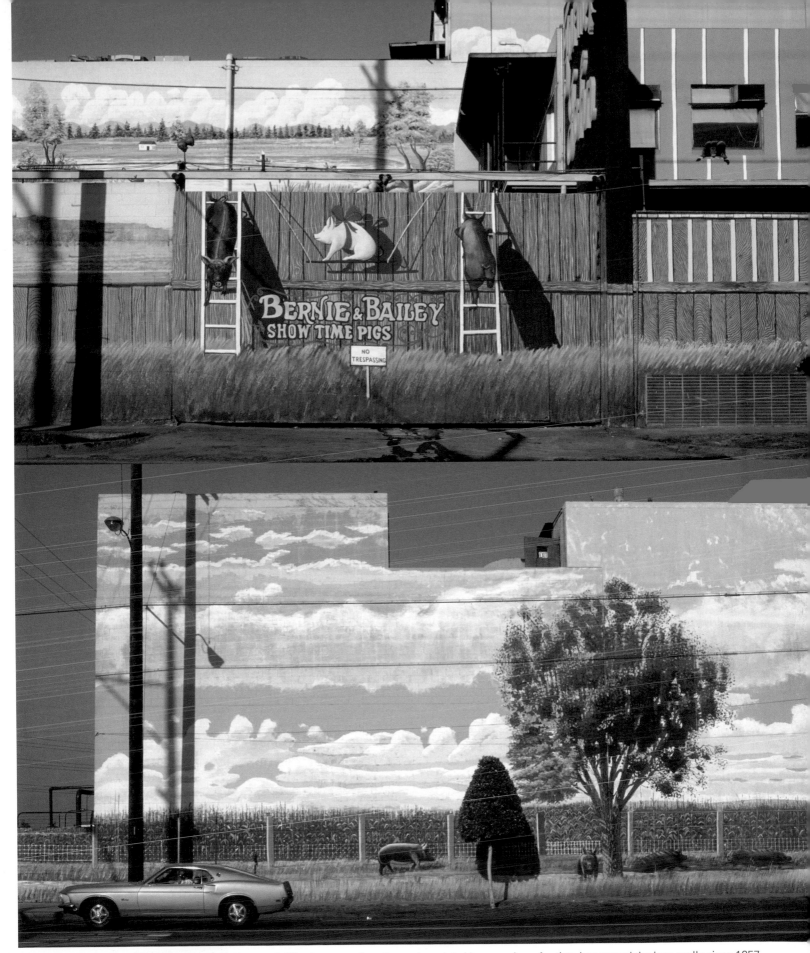

At the Clougherty Meat Packing Company in Vernon, California, a mural continuously updated by a number of artists has graced the long walls since 1957. *Farmer John's Hog Heaven* depicts pigs at play, roaming free, while inside the walls they are being slaughtered. Those working on this ongoing project include Les Grimes (from 1957 to 1967), then Arno Jordan for a 30-year period, and Philip Slagter from 1999 to 2004. Photos: Peter Mackertich

At Les Abattoirs de Casablanca the approach is freeform, with large numbers of artists laying trails of paint throughout this massive French colonial complex built in 1924 and now largely derelict. Many such interventions in the city are facilitated by Studio IWA.

In the kasbah of Tangier, images of the sea show what would be visible if a wall were not blocking the view.

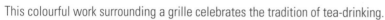
This colourful work surrounding a grille celebrates the tradition of tea-drinking.

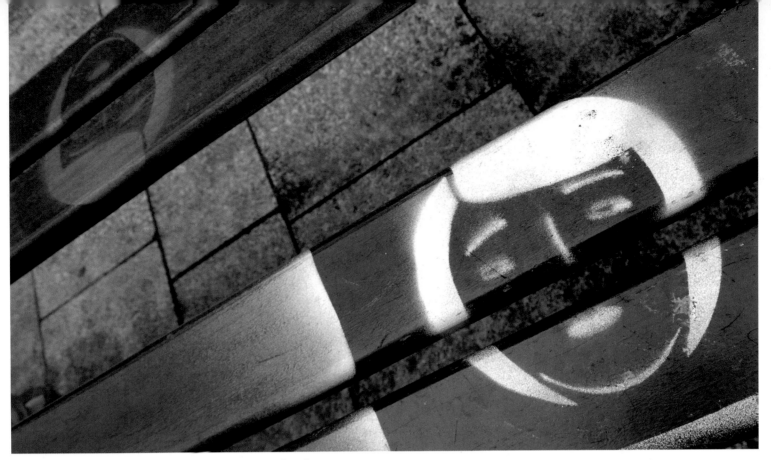

In Paris, you may need to look before you sit on a street bench.

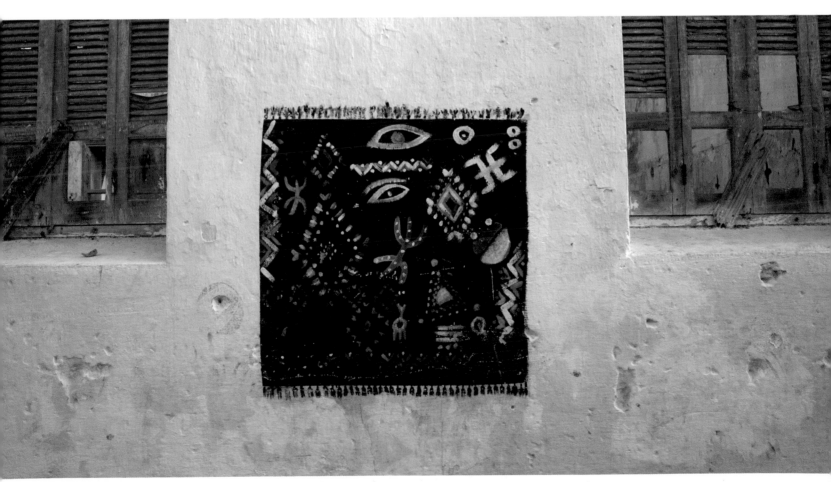

At Azemmour, on the edge of the Sahara, realistic images of carpets line the walls of the medina. They appear to have the asymmetrical patterning of Berber origin rather than the abstract 'keyhole' design of an Islamic prayer rug.

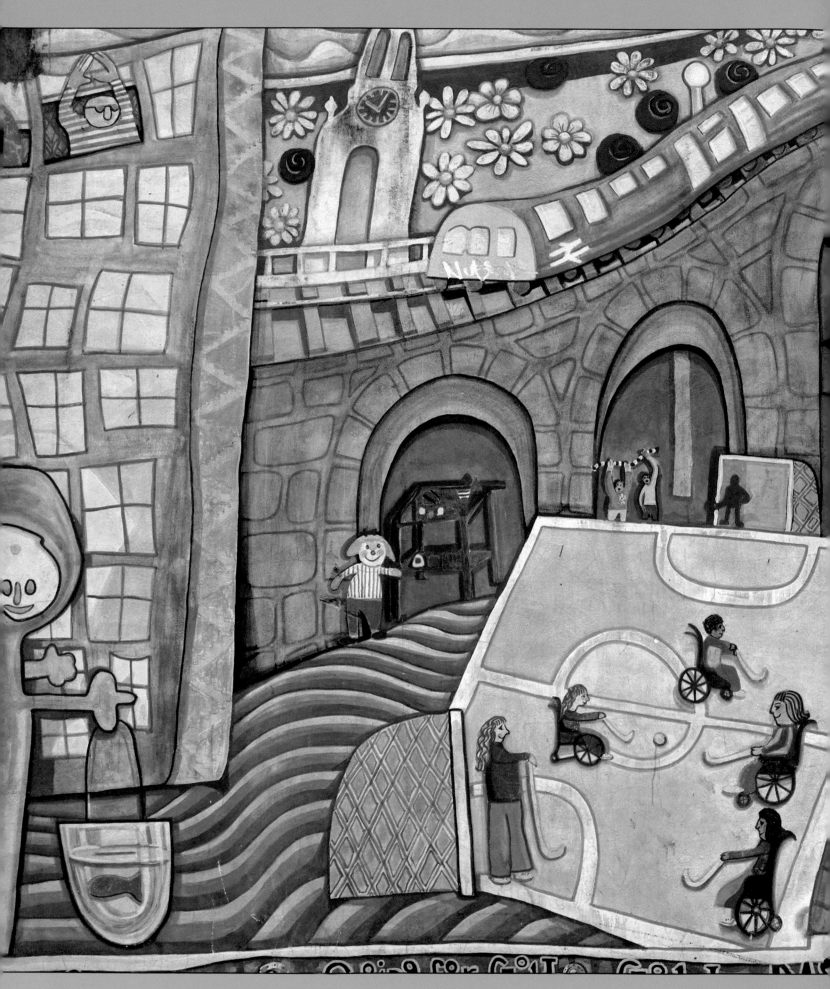

ISSUES

Although it may seem to be specific to contemporary urban art, wry sociopolitical commentary has a long and illustrious history. One notable example of earlier practitioners is Russian émigré artist Marc Chagall who, when he lived in Saint-Paul-de-Vence in the south of France in the 1920s, painted scenes from the 1917 revolution on railway trucks, some of which travelled on towards his homeland.

Unpredictable weather conditions and the illegal positioning of much urban art are occupational hazards that make it extremely difficult to execute; this element of danger and risk means that a number of its practitioners have earned cult status. The serious issues-related messages which some artists are determined to impart have also gained them further public respect for their work.

Public art by Gary Drostle, London

SUBVERTISING

Environmental neglect and defilement, the rise of consumerism, the horror of war, the unbridled growth of multinational companies and the broken promises of politicians worldwide – these are some of the issues that preoccupy urban artists both locally and globally. Artwork commenting on such malpractices can encompass various street art activities. It includes the guerrilla 'subvertising' (subversive advertising) of reappropriated logos prevalent during the 2012 London Olympics.

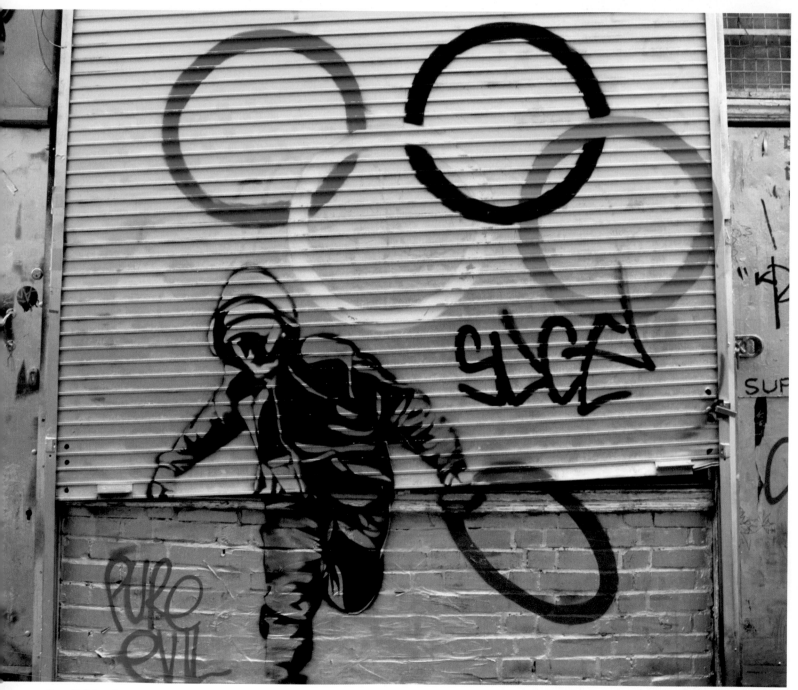

Pure Evil, London

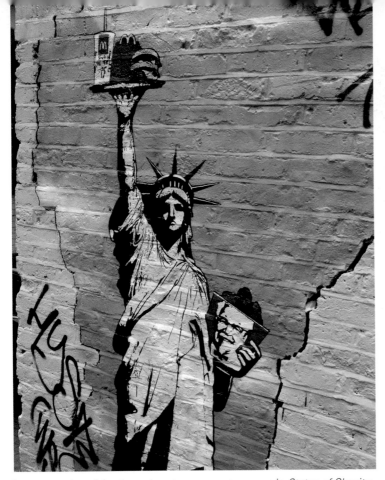

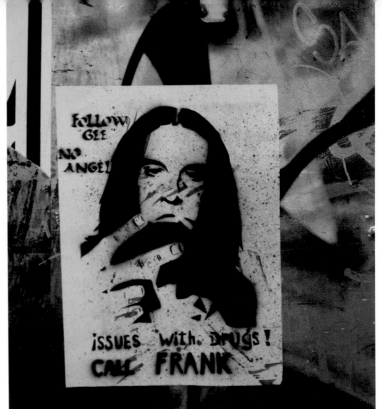

Gee parodies government health awareness slogans using the dysfunctional workshy character Frank from the UK TV show *Shameless*.

Icon uses subvertising to comment on corporate excess in *Statue of Obesity*.

Subvertising, brand-hacking or culture-jamming involves the reuse of recognizable logos, characters or slogans that are altered to challenge the credibility of the original advertisements, political slogans, newspaper headlines or broadcast depictions.

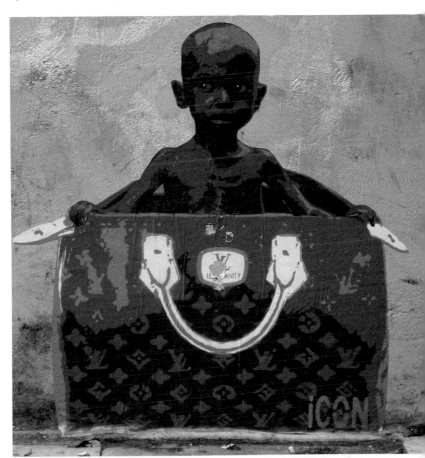

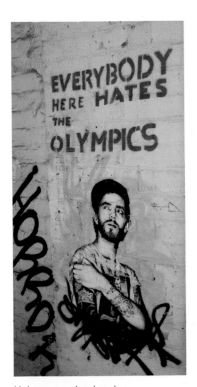

Unknown artist, London

Loretto, London

Icon's *Less Vanity* takes an image of an African child and places him an open Louis Vuitton bag to illustrate the dichotomy of celebrities who are happy to be seen advertising expensive products in some situations while airing their concerns about child labour and globalization in others.
Photos: Doralba Picerno

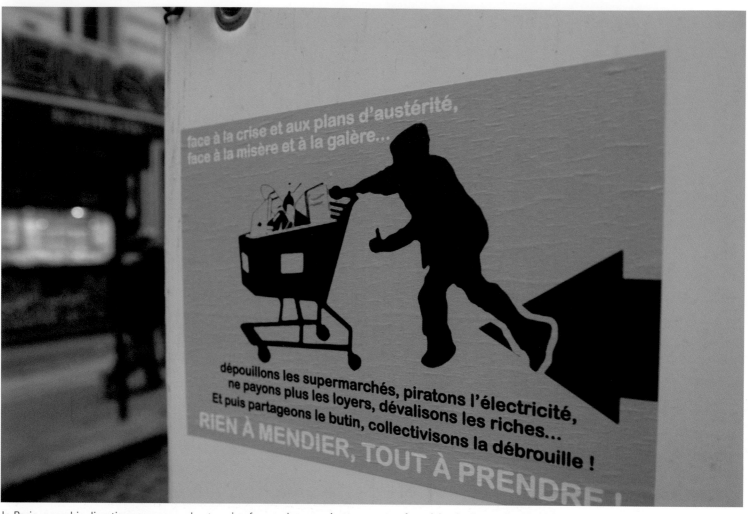

In Paris, anarchic directives recommend not paying for goods or services as a way of surviving in times of austerity.

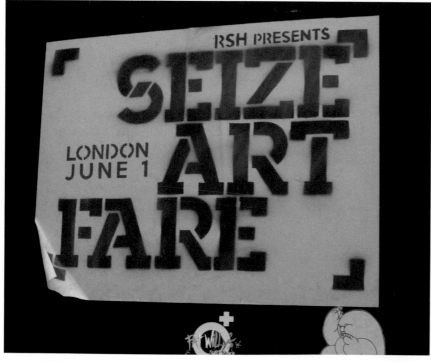

Above: RSH comments on the big gallery corporate art fair Frieze.
Right: Austrian artist Reinhard Schleining uses wordplay to make a point in Whitechapel, London.

96

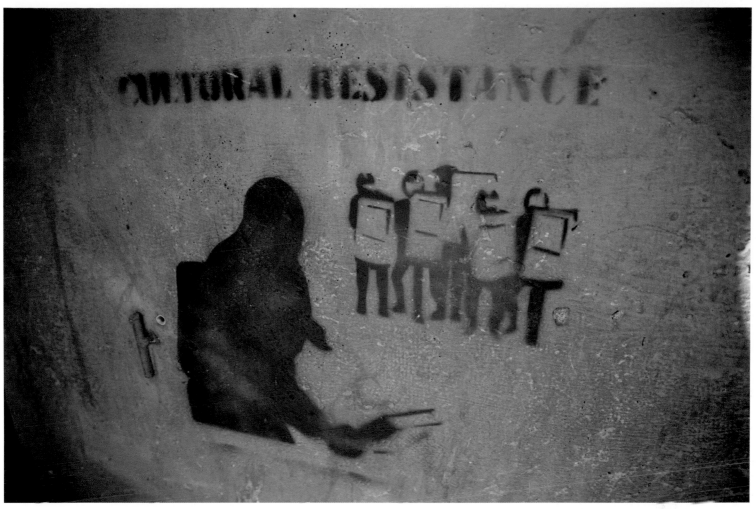

Cultural resistance demonstraters throw books at police armed with smartphones as shields, Rome.

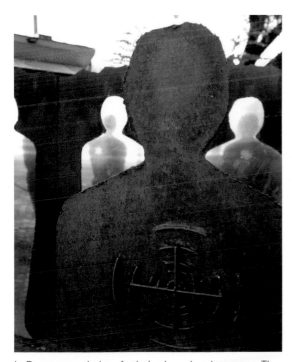

In Rome, a reminder of ethnic cleansing; known as *The Pink Triangle Monument,* five metallic cutouts with targets are identified by their religion, ethnic group, nationality and political or sexual preference.

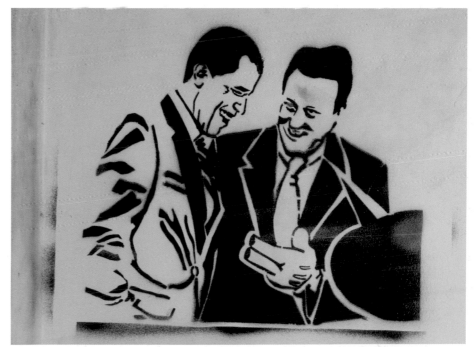

In this piece in Barcelona, British Prime Minister David Cameron's hand is a Mickey Mouse glove mutated into a double-barrelled pistol. The blacked-out speech bubble suggests that his conversation with US President Barack Obama is censored.

LIFESTYLE CHOICES

Grassroots movements wishing to maintain the cultural identities of urban communities around the world are constantly under threat. They increasingly use art placed near large corporate developments to raise awareness of the intentions of big business. The art underlines the exploitation of ethnic creativity when areas with a rich cultural heritage are sold off to the highest bidder, local rents are forced up and communities are destroyed through aggressive 'lifestyle marketing'.

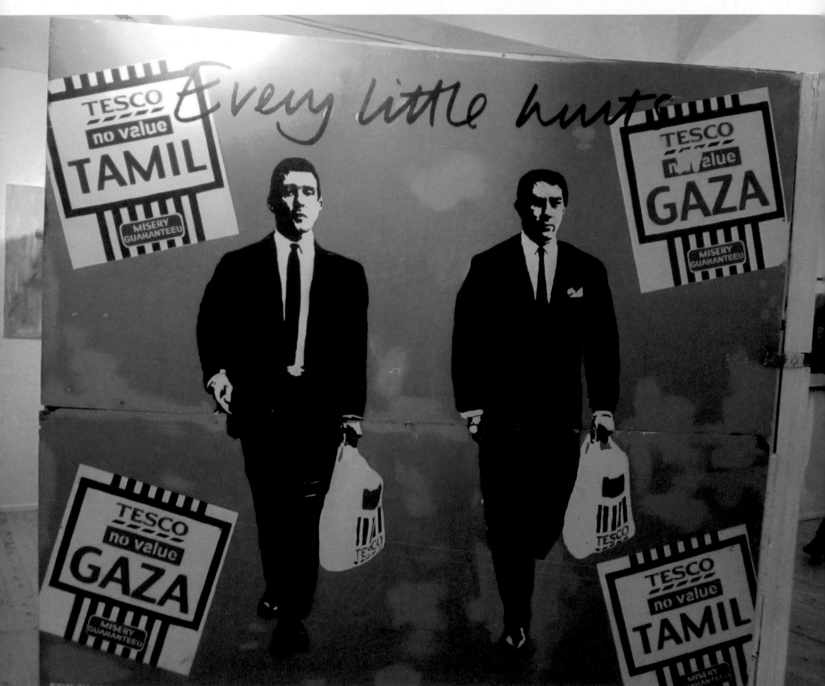

Art Below, a London public art enterprise, brings attention to the role of a British superstore chain in supporting oppressive regimes around the world. T.wat's depiction of notorious gangsters the Kray twins, armed with shopping bags, was placed opposite the Houses of Parliament while anti-war protesters camped outside. Here it forms part of the Peace Project exhibition at Gallery Different, London. Photo: Sheridan Orr

98

Urban art that addresses issues of empathy and collective responsibility prompts the viewer to consider how his or her actions and lifestyle choices impact on others.

Despite his many distractions Banksy still maintains a presence, whether commenting on consumerism with the slogan 'Sorry, the lifestyle you ordered is out of stock' daubed at an east London traffic intersection or, as here, with a controversial observation on child psychology. From the Urban Masters exhibition, London

Housing issues, Barcelona

HUMAN RIGHTS

Turning the spotlight on human rights in South Africa, Faith47 reproduces texts from the Freedom Charter, an original statement of the core principles of the anti-apartheid movement. Faith47 melds these flowing hand-drawn scripts with striking imagery to highlight the continuing economic and social injustice still experienced by many South Africans. She has also worked in the Netherlands and Switzerland, countries that are seen to champion human rights. Photos: Sheridan Orr

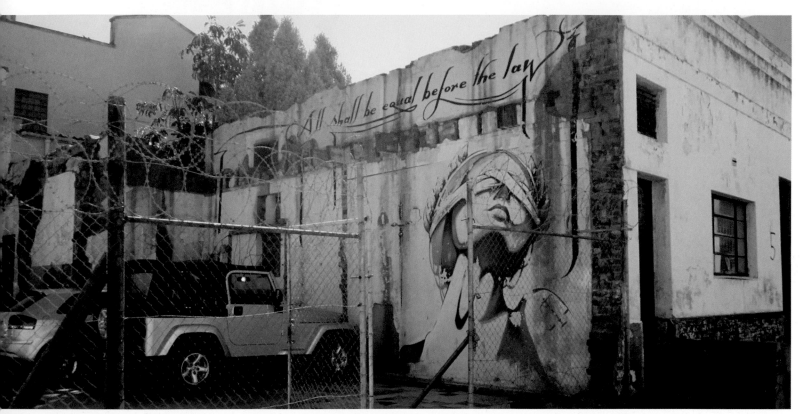

Above, Faith47 quotes the former Afrikaaner anthem of South Africa which translates as 'We are for you South Africa' and blends it with 'calligraffiti', an emerging trend melding calligraphy and graffiti. These works examine current issues and longstanding concerns, mirroring public sentiment.

Here, Cape Town-based artist Mak1one uses numbers to illustrate what happened in particular years of South African 20th-century history, framing pictoral narratives within the relevant numerals for the decades 60, 70, 80 and 90.

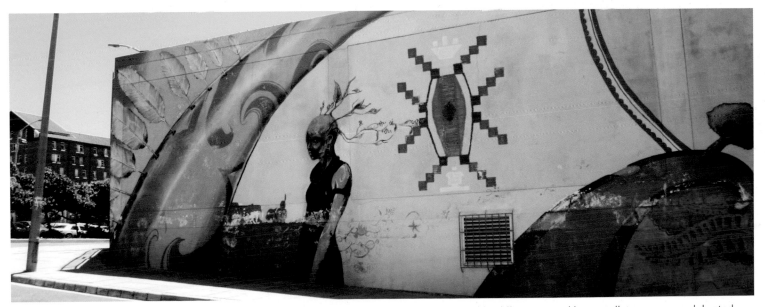

In a ruined building, Mak1one has painted a dream of peace in an alternative reality, inspired by the words of Bob Marley.

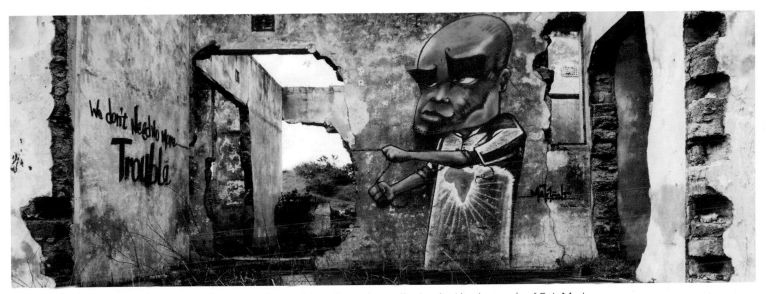

Interracial collaboration is a healthy sign of the new South Africa, where cultures around the world, while separated by vast distances, are celebrated. Mak1one comments, 'The concept of the mural is to show that actually we share a lot, from design, clothing, ways of worshipping, respect for the earth and rituals. In essence, we are all connected, no matter what barriers we put between ourselves.' He designed this piece, which was painted by Faith47.

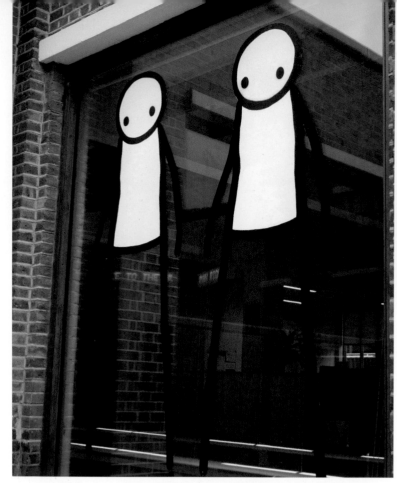

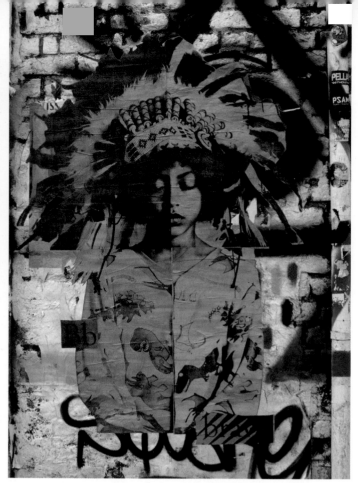

Amnesty International commissioned Stik to decorate their office window in London with two vulnerable figures that could be from anywhere in the world.

A Native American squaw in dinosaur-patterned pyjamas, a metaphor for the extinction of a race. Unknown artist, London.

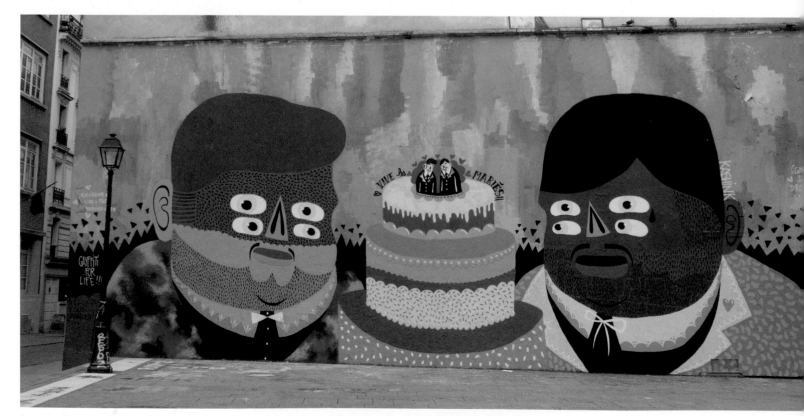

In early 2013, a crowd of 50,000 people gathered in Paris to march against proposed pro-gay marriage legislation, the largest right-wing protest in the city for 30 years. This wall by a canal in the French capital illustrates the opposing view and celebrates the notion of a cosmopolitan city with a rich history of personal freedom. Kashink, one of the very few active female artists on the French urban art scene, depicts a same-sex marriage presided over by her trademark quad-eyed humanoids, who act as guardians over the newlyweds.

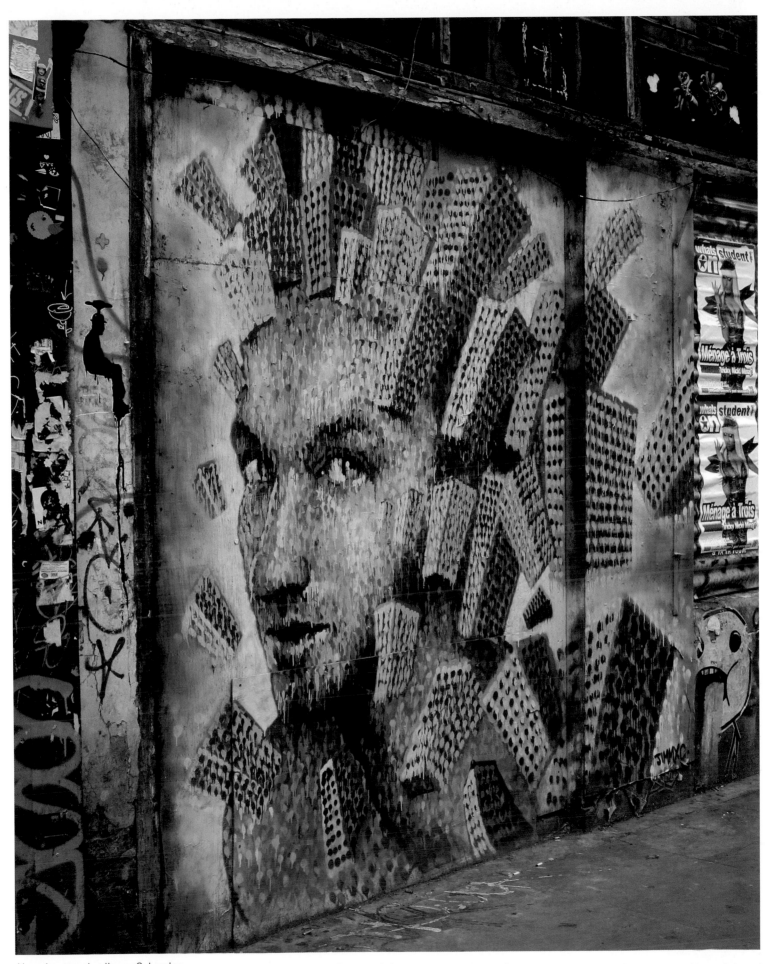

Homelessness by Jimmy C, London

PUBLIC HEALTH

Philadelphia has nurtured a culture of murals that not only embrace stars of the city's substantial, diverse and influential musical heritage, but also its inclusive public health objectives. The City of Philadelphia Mural Arts Program is the largest public art programme in the USA and one of its most outstanding pieces is *Independence Starts Here* by Donald Gensler, which stretches across seven storeys and 204 sq m (1220 sq ft) of Hahnemann University Hospital. The ground-level viewer has a Lilliputian perspective of Gulliver-sized actors within a diverse and extraordinary community of people facing the challenges of disability.

A transparent tapestry overlays the design, giving Braille translations and the entire American Sign Language (ASL) fingerspelling alphabet with 12 corresponding hands spelling out the word 'independence', created by students from the Pennsylvania School for the Deaf. This mural is testimony to the direct collaboration between Gensler and the community, as well as to the support and notable Outreach programmes provided by the hospital.

Detail with Braille symbol

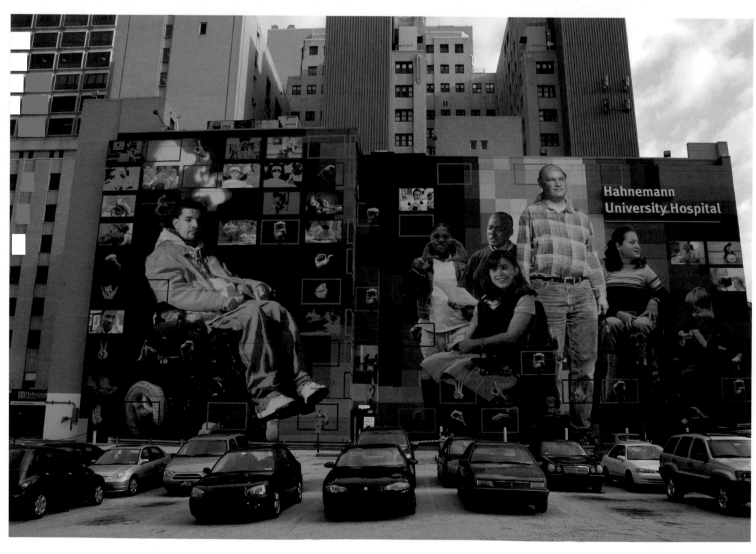

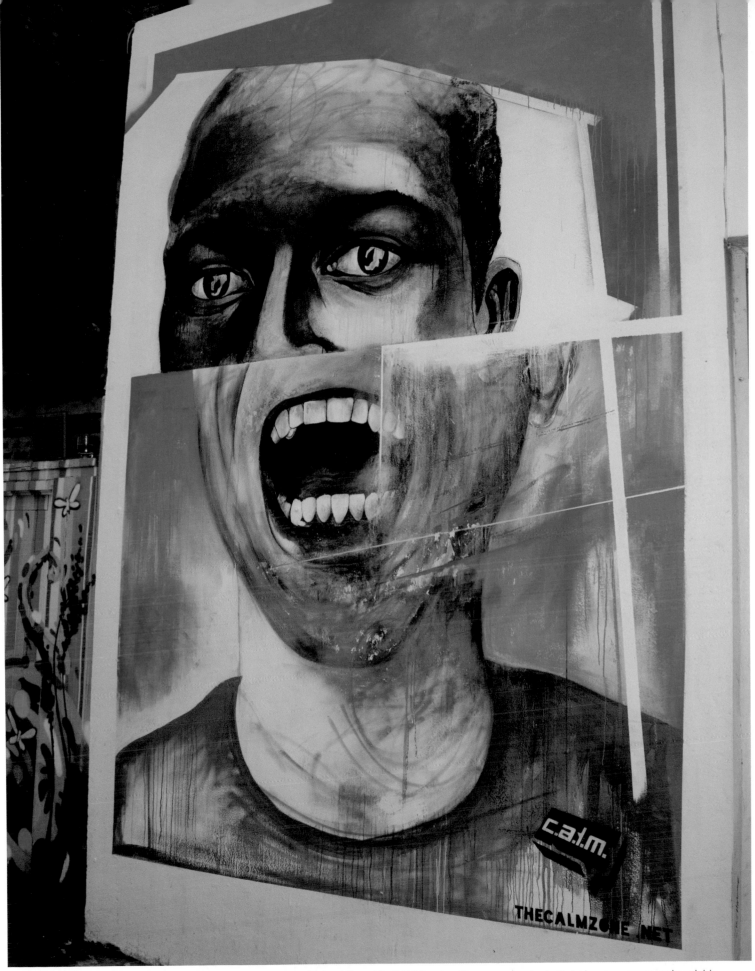

This work was created by Ben Slow for the Campaign Against Living Miserably (CALM), a health awareness body that aims to prevent male suicide. Mental anguish is a subject close to Slow's heart, so he works to promote discussion of the emotional problems suffered in silence by many men.

ENVIRONMENT

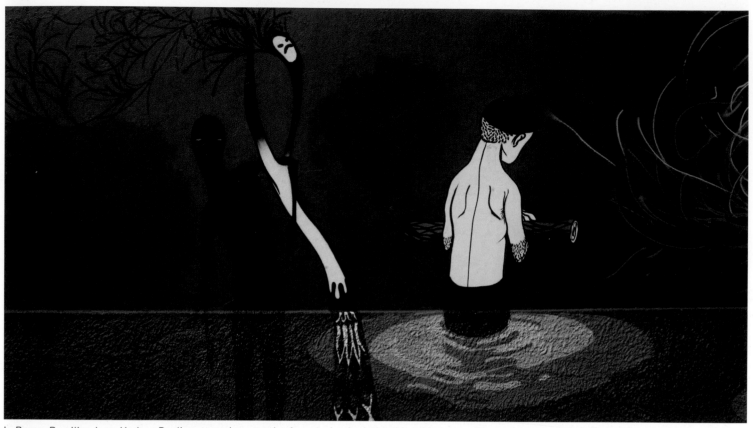

In Rome, Brazilian-born Herbert Baglione examines man's often strained relationship with nature. His stark human figures interacting with the world around them cause the viewer to pause and consider his or her own impact on the environment.

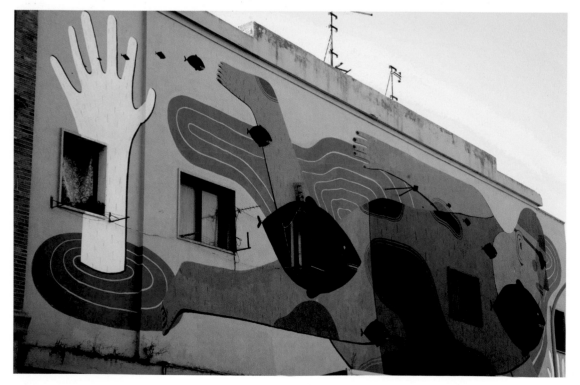

While his style is inspired by storybook illustrations, Agostino Iacurci's narrative is about coexistence. His work includes a massive frieze for Saba School in Algeria and helping inmates to paint huge murals in the maximum security section of Rebibbia Prison, Italy. In Rome, Pescheria Ostiense commissioned this large-scale piece for the front of a building that houses their wholesale fish distribution business. In this mural Iacurci suggests a utopia of sustainable living.

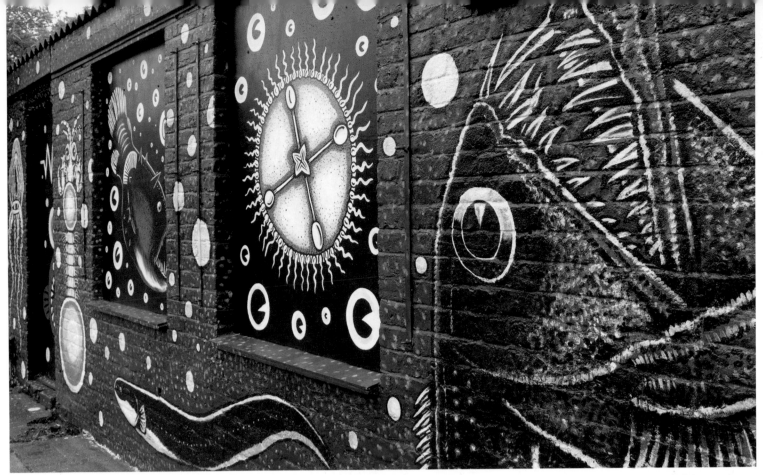

New Zealand-based muralist Bruce Mahalski came to London for a month to make a site-specific work that references the electromagnetic laboratories that once occupied the riverside at Orchard Place by East India Dock. *Electric Soup* takes its name from William Heath's hand-coloured print *Monster Soup*, satirizing the quality of Thames river water during the early 19th century, which had been made undrinkable through sewage and industrial waste.

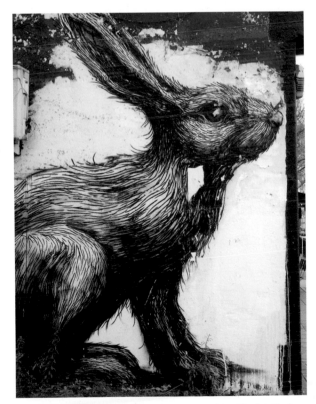

ROA's huge, beautiful feral creatures, made with detailed strokes of black paint, appear on the sides of buildings and on large pieces of discarded material that could be the homes of the animals he paints. This hare is in London.

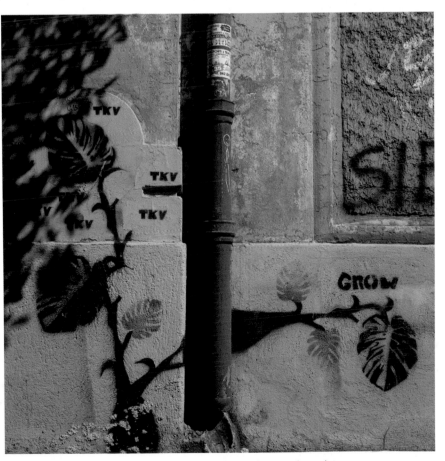

In central Rome, TKV grows plants in the shadows of empty factories.

OTHER ISSUES

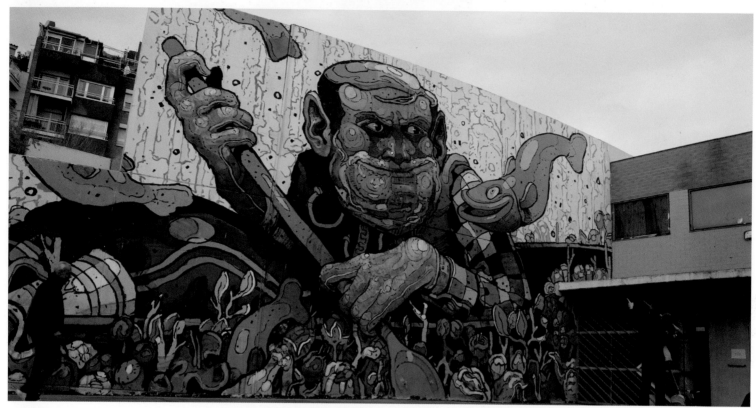

At Biblioteca Guinardó in Barcelona, fine artist Aryz has painted *Mur d'entrada* on an architectural detail by the library entrance.

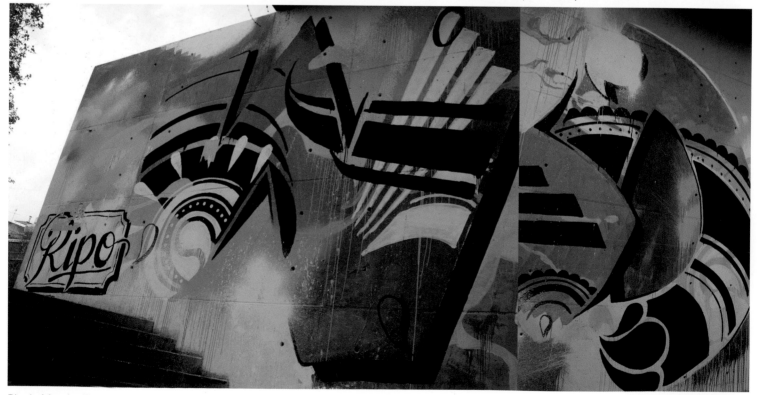

Ripo's *Mur Jardins d'Hiroshima* graces a building in Barcelona.

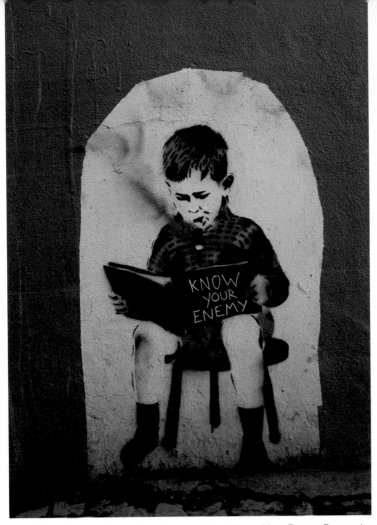

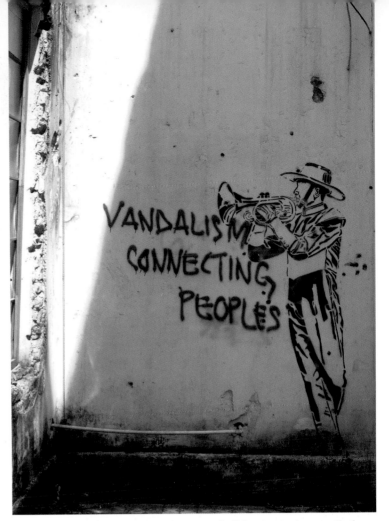

A child smoking a cigar reads a book entitled *Know Your Enemy*. Reputed to be by Banksy, this work in east London brightened up a dark alley and was welcomed by residents, according to local media.

In Kuala Lumpur, an abandoned city centre building hosts the stencil of a bugler announcing 'Vandalism Connecting Peoples'. Such criminal activity, while reprehensible to some, is embraced by others.

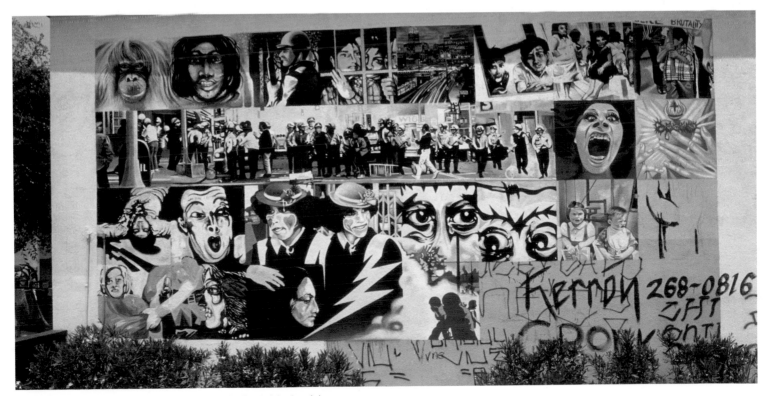

A window on the world, Los Angeles. Photo by Peter Mackertich

HOMAGE

There is now an increasing tendency for artists to go beyond celebrity culture for their subjects, highlighting those who have brought about great change for the good of humanity or achieved status within their communities for their selfless work. Some homages are simply personal tributes to members of an artist's own family.

Hieronymous Bosch's visionary work is commemorated on the wall of this restaurant kitchen in the east of Paris. French artist ROTI seeks to make the street into 'a good museum'.

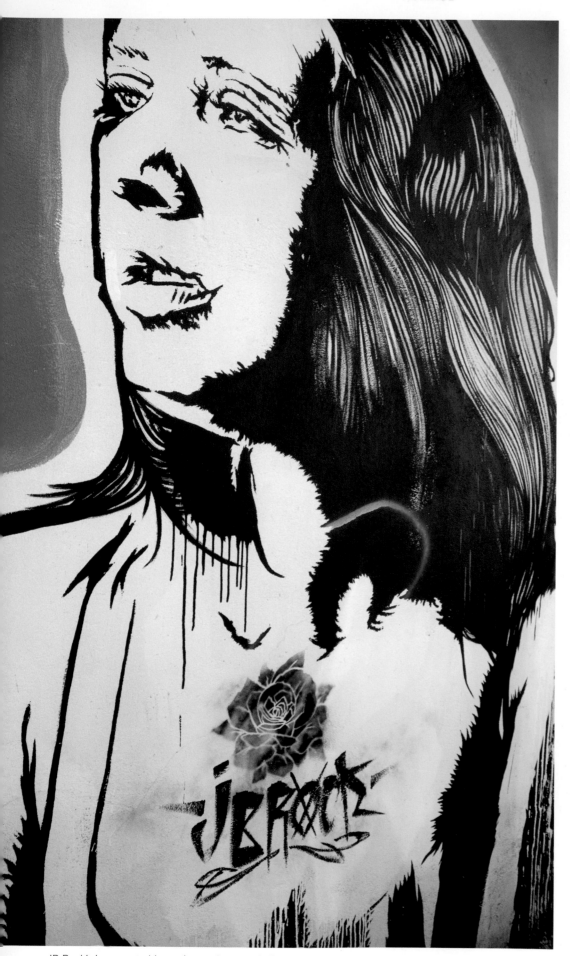

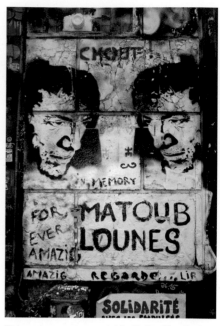

This poignant memorial in Belleville, Paris, celebrates Matoub Lounès, an outspoken advocate of Berber rights in Algeria.

More than a century after Elias García Martínez made a fresco of Christ entitled *Ecce Homo* in the church of La Misericordia de Borja, damp was seeping into the plaster walls and the painting was flaking off. Church volunteer Cecilia Gímenez, aged 81, proceeded to repair the damage. Unfortunately her enthusiasm did not make up for her lack of artistic skill. This sketch in Cadiz pays homage to her efforts.

JB Rock's homage to his mother, to be seen in Rome.

In Morocco, a Mercedes is seen breaking through the word 'Casablanca', a homage to a famous original piece
on the Berlin Wall that showed a Trabant breaking through the Iron Curtain of East Germany.

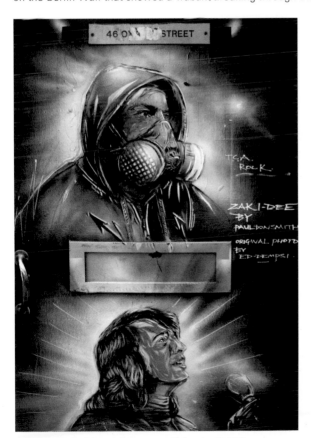

Paul 'DON' Smith celebrates graffiti artist Zaki Dee
above another of his works honouring Robin Gibb of
the Bee Gees, who campaigned to get a memorial built to
Bomber Command, as his father flew many missions.

In London, the renowned scientist Michael Faraday is celebrated with those who
developed his innovative ideas in maritime signalling. Paul 'DON' Smith was commissioned
by Trinity Buoy Wharf Trust to capture the spark of creativity in childhood that leads to
adult ambition. The artist has taken Faraday's signature and turned it into a tag.

113

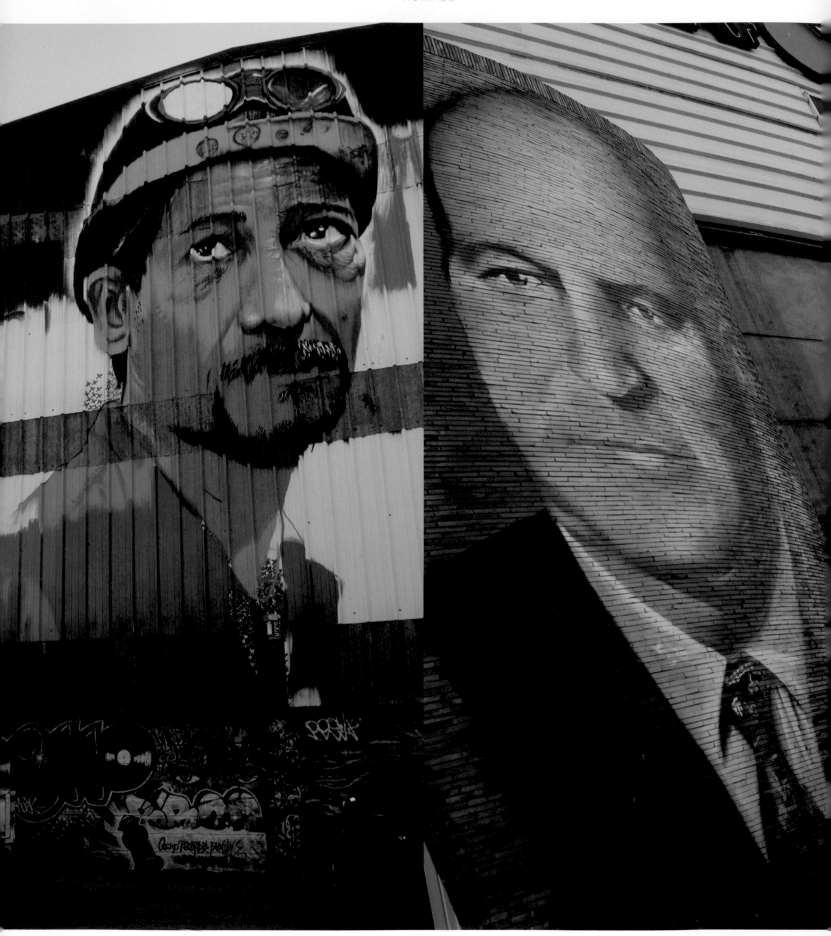

Founders and workers are celebrated at the Mafoder plant in Morocco. The work of artist Morran Ben Lachen dominates the plant's corrugated walls and entrance gates.

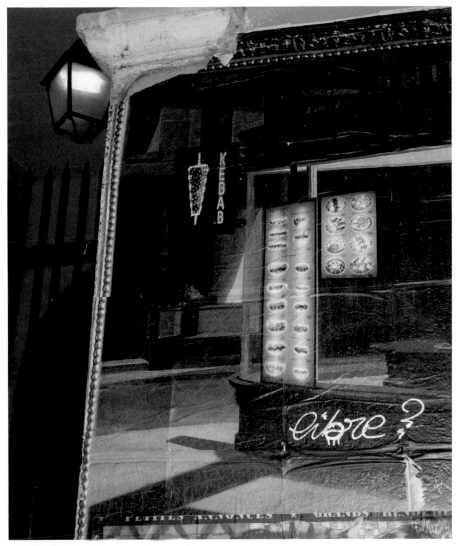

Edward Hopper's famous painting *Nighthawks*, an observation of a New York corner diner, is adjusted here to show a kebab shop on a poster in Paris.

Mr Brainwash's team churn out industrial quantities of homages such as this version of Thomas Gainsborough's *Mr and Mrs Andrews (1748–50)* with David and Victoria Beckham as the wealthy couple pooling their assets.

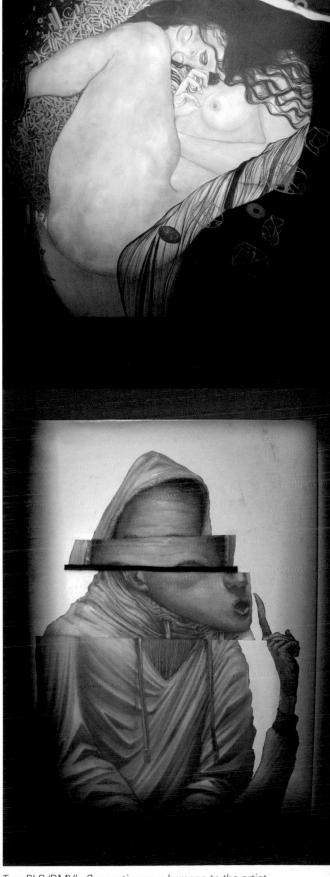

Top: BLO/DMV's *Conception* pays homage to the artist Gustav Klimt.
Bottom: BOM.K/DMV's *Homage to the Anonymous Masters of the 20th Century*

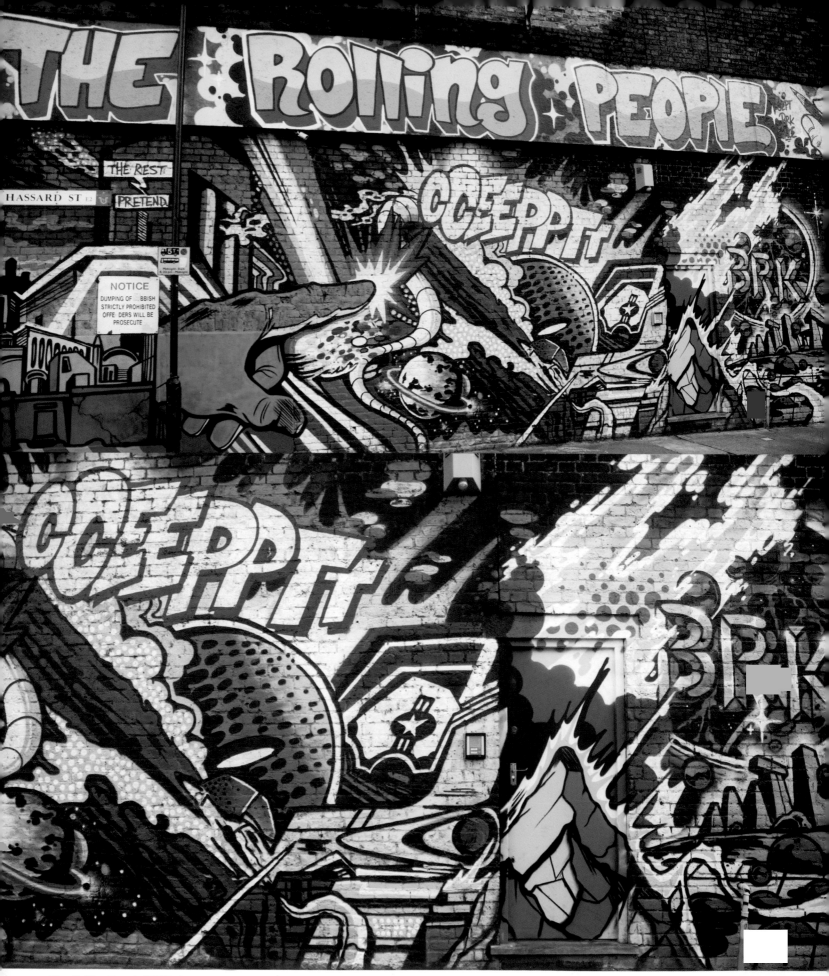

The Rolling People (TRP)'s four-man collaborative work pays homage to Marvel Comics while also acknowledging a debt to Roy Lichtenstein. TRP mixes Lichtenstein's text and images with galactic elements from the Marvel stable of superheroes. Photos: Doralba Picerno

Rone pays an overt tribute to Lichtenstein in *That's the Way It Should Have Begun But It's Hopeless,* using acrylic polymer on collaged found text. Lichtenstein reproduced enlarged dot gain from comic-book lithographic reproductions to explore and experiment with the processes of commercial art.

Unknown artist, London

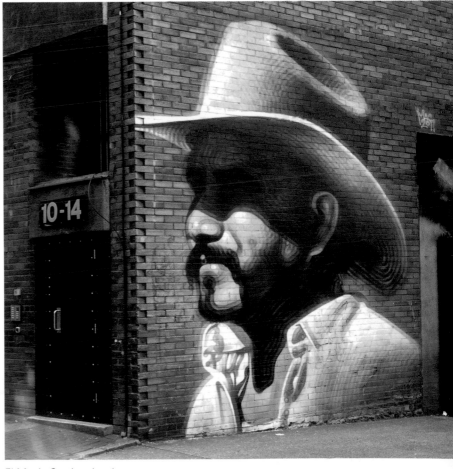

El Mac's *Cowboy,* London

NEW IDEAS

From the urban artist's trinity of humorous trickery, peer acknowledgement and serious campaigning emerge some new ways of engaging with the public. These may include elements of fine art, performance, viewer interaction or an amalgamation of several different practices.

The word 'calligraffiti' was coined by Amsterdam-born Shoe, aka Niels Meulman, to describe a melding of gritty graffiti and decorative typography. In Shoreditch, London, Eine's expertly illuminated script outside the office of advertising agency Mother reads 'tag', a word that resonates with graffiti artists everywhere.

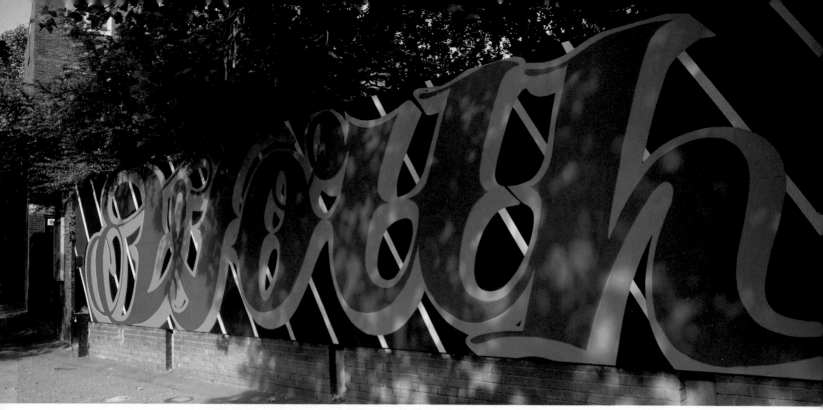

On a site that once hosted Eine's 'CHANGE' text, an artistic plea to young people to stop carrying knives, the artist has now painted 'WORTH' and 'MORE'. This art was produced in partnership with the Flavasum Trust, a charity using the arts to warn young people of the danger of carrying weapons. Photos: Doralba Picerno

The blending of street art and calligraphy is not confined to the West. In Casablanca, Arabic scripts have been distorted into figurative shapes.

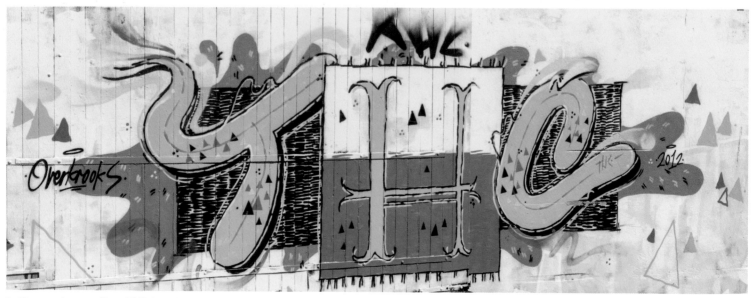

In Newcastle upon Tyne, THC from Sète, France, has transported letters on a magic carpet of improvisation with Overkrooks' familiar triangular portals framing the rendered text. 'Overcrook' is skateboard terminology for grinding along a rail or ledge.

120

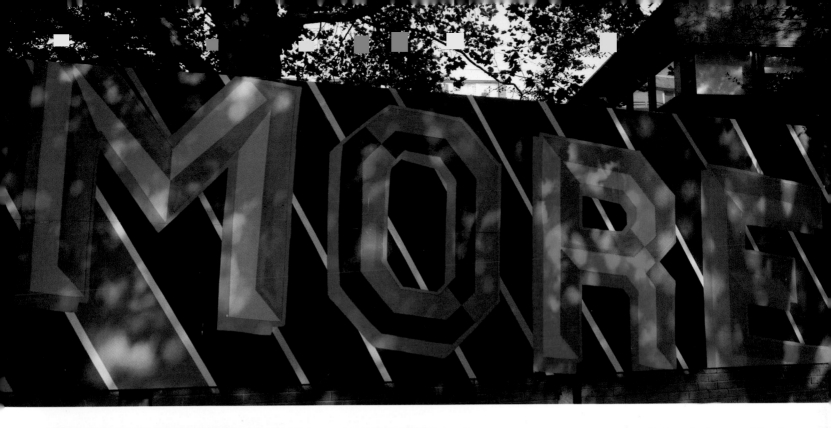

Reverse graffiti or 'grime writing' is a process perfected by Benjamin Curtis, aka Moose, Belgian artist Stefaan De Croock, aka Strook, and Alexandre Orion, who created Ossário, an intervention in one of São Paulo's road tunnels. The artists spent two weeks manually removing thick layers of soot built up by exhaust emissions.

Left: 'Clean art' pioneer Moose uses high-powered water jets to etch designs from layers of city dirt covering walls and walkways. For 2012's Thames Festival he produced *Rhyme in Grime* on a pier in Southwark, south London.

For the NuArt Festival in Stavanger, Norway, Herbert Baglione created intricate tags to commemorate the 69 young people who died in the 2011 massacre on the island of Utøya.

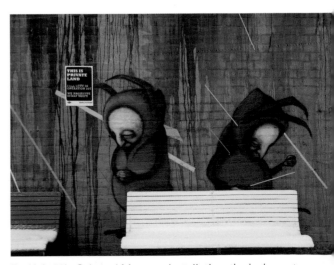

For Unit 44's *Selected Moments* installation, the inclement weather in this piece by Remi/Rough & Stomie Mills was matched by a real northern winter. Photo: Doralba Picerno

121

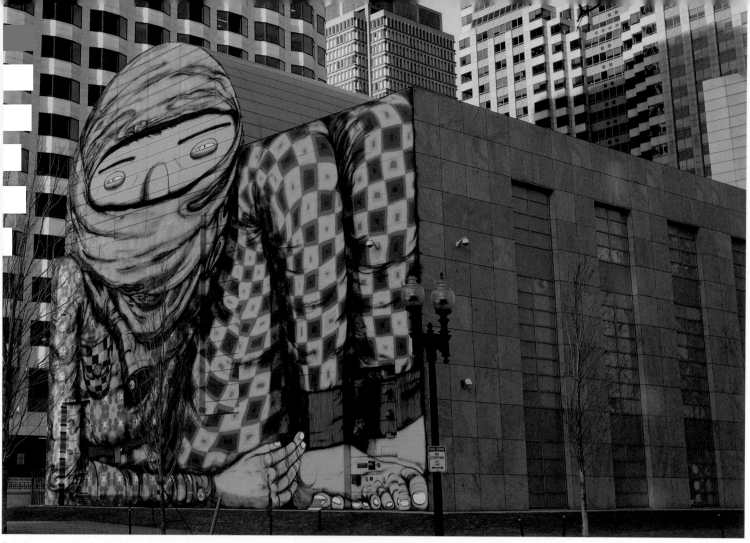

Existing building shapes are used to great effect by Brazilian twins Os Gemeos at Boston's Institute of Contemporary Art in Massachusetts, where the outline of a crouched figure traces a ventilation shaft.

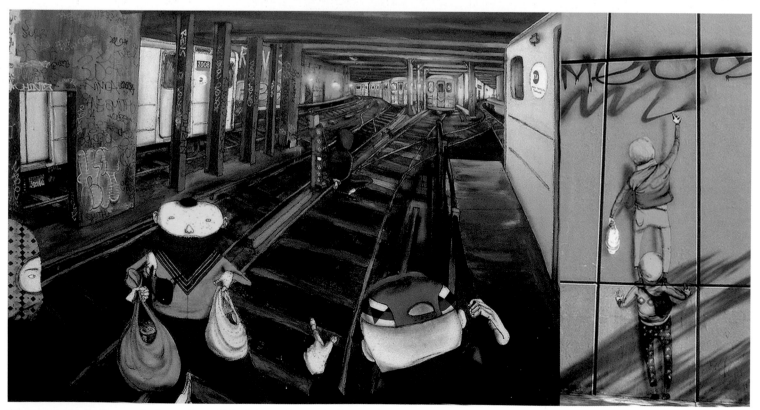

Other works by Os Gemeos look at train graffiti origins and the twins' own collaborative practice.

Ben Wilson is best known for his delicate miniatures painted directly onto the chewing gum that litters city streets. Another medium has now caught his attention and, while more easily shifted, it is no less a symbol of global pollution – the discarded cigarette butt.

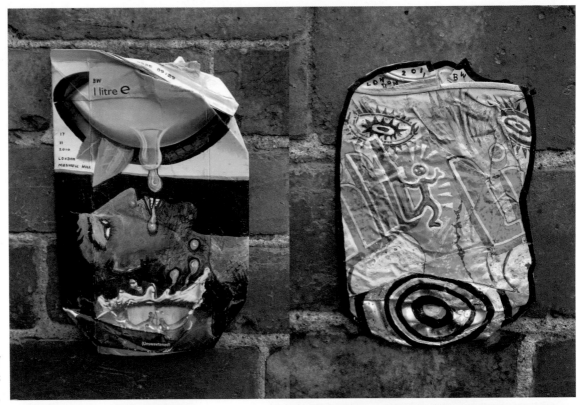

In a similar vein, Ben has patiently moved onto other objects such as empty drinks containers.

By replacing the cigarette butts where they were carelessly chucked away, Ben draws attention to our throwaway society and questions the validity of certain types of cultural experience. Photos: Ben Wilson

Wildstyle extremists Die Looted take their inspiration from LA rappers Raiders Klan, drawing on the mystical masks of Egyptology and secret society symbolism. Their pure yet disrupted graphics owe something to Vaughan Oliver's modernist designs for the 4AD record label.

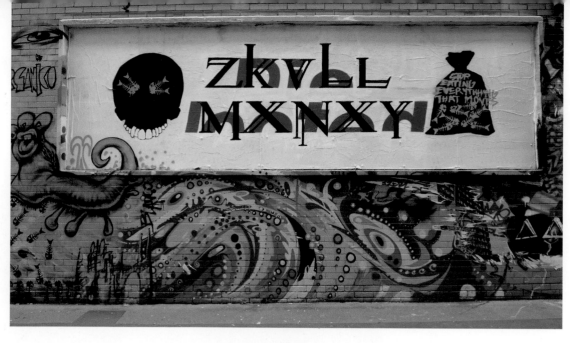

In this work by Die Looted, the word skull becomes 'zkvLL'.

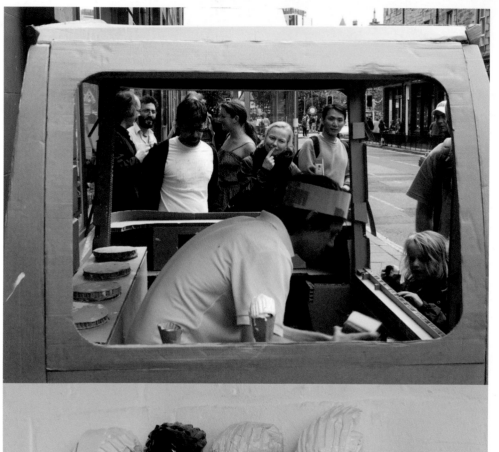

Some new urban art goes beyond two-dimensional expressions on a wall. Pioneers experiment confidently with materials previously untried on the street, turning our cities into a three-dimensional playground. At the same time, lateral thinking avant-gardists are emerging. William Alexander has meticulously re-created a scaled-down 1960s vehicle – out of waste cardboard. A particularly comforting symbol of childhood summers, Will as IceCreamVanMan has delighted and puzzled audiences in locations as diverse as the sidewalks of Manhattan to a guerrilla appearance in the Turbine Hall of the Tate Modern in London.

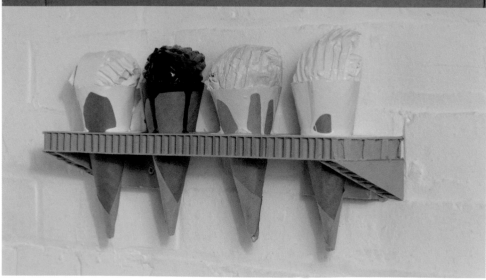

The artist designed the van from detailed blueprints which were exhibited in a former shop, the Total Kunst project space in Edinburgh, while the van itself explored the nearby streets during the summer arts festival. The vehicle has a cardboard steering mechanism and four pots of variously coloured paints that are used to create the inedible toppings on rolled cardboard cones. These are made to order for members of the public who encounter IceCreamVanMan.

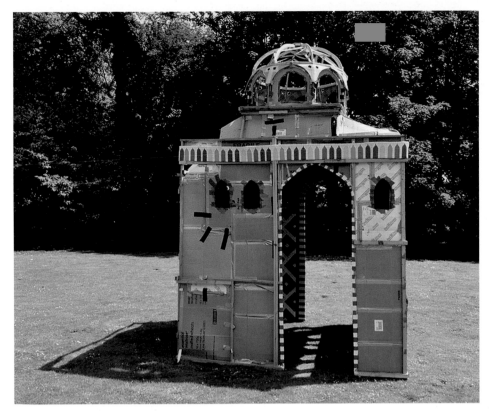

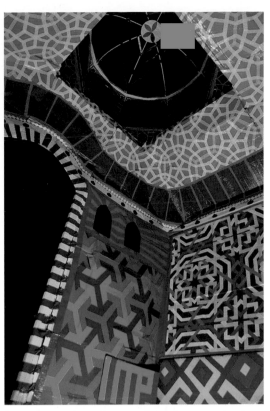

Morris Wild is a young artist who has used packaging left over from his job at a supermarket to create temporary structures that reveal a world of wonders inside.

The mosque shows its materials of construction in daylight, but gains a mystical aura after dark.

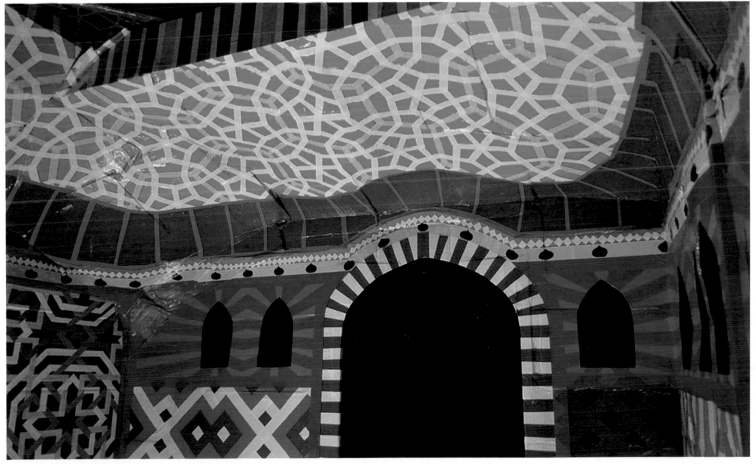

Morris's work examines the crossover between abstract art of the Middle East and figurative traditions of western Europe. In his cardboard mosque, Matisse-inspired cutouts mingle with geometrically arranged and meticulously executed patterns created from coloured duct tape.

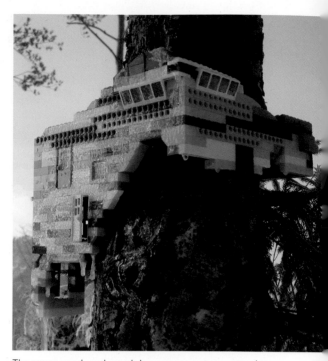

The mass-produced, modular components are used to create structures that mimic the habitats of both humans and birds, conjuring a sense of experimental play. In the Korean winter, tiny stalactites and sheets of ice give the creations an air of otherworldliness.

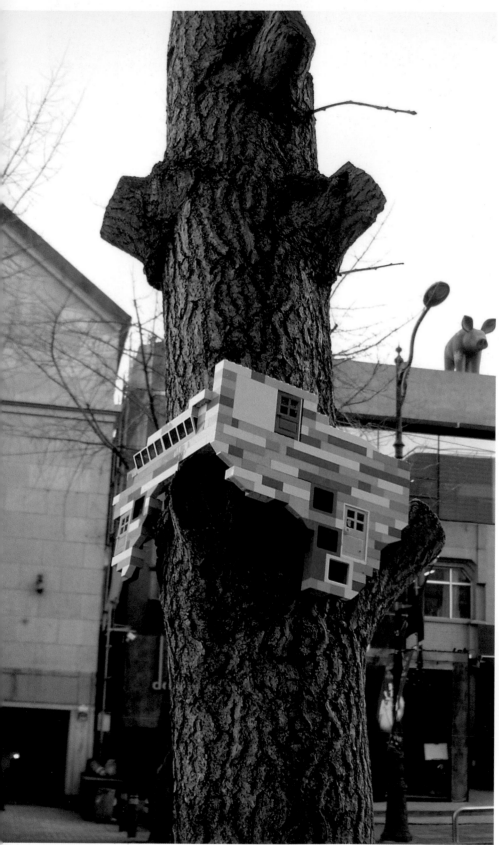

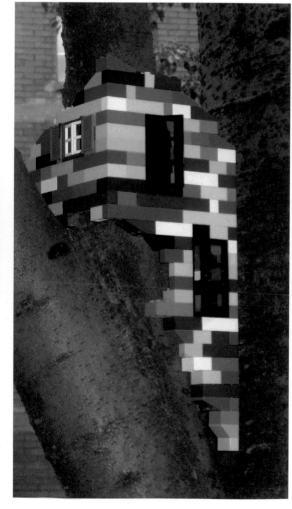

Korean interventionist Jaye Moon leaves constructions made from colourful toy bricks nestled between the branches of roadside trees, allowing space for the plants to grow. Participation from passersby is encouraged, as the artist sees the creative input, especially by children, as an example of real engagement with these free-form architectural experiments. On revisiting the sites, Jaye often discovers changes, with doors opened or closed, and bricks missing or even added. Photos: Jaye Moon

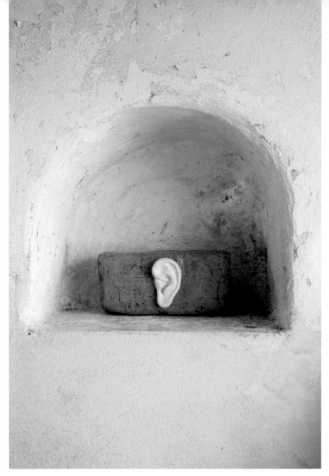

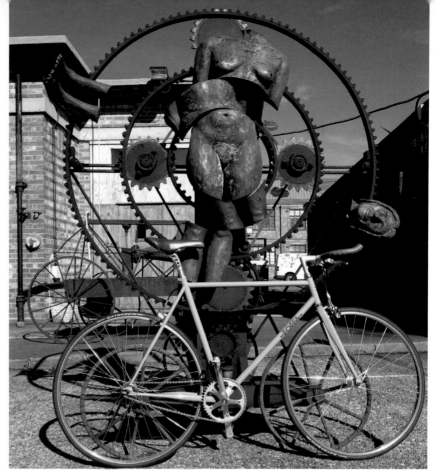

In Guangzhou, the main industrial region of China, artist Michael Mayhew asked a brick factory to create moulds with the impression of an ear pressed into the clay. From this he made ten sculptures of ears on handmade bricks as gifts for people who had listened to and assisted him on his journey. During the Cultural Revolution, millions of school children made bricks as part of their education.

Andrew Baldwin leaves a constant yet ever-changing selection of recycled machine parts at various points along the rivers Lea and Thames in and around London. Taking his cue from Tinguely, Takis, Panamarenko and other artists dealing with movement, Andrew creates figures in a space of depth and apparent chaos that are never formally planned outside of his head. Photo: Ellis Leoper

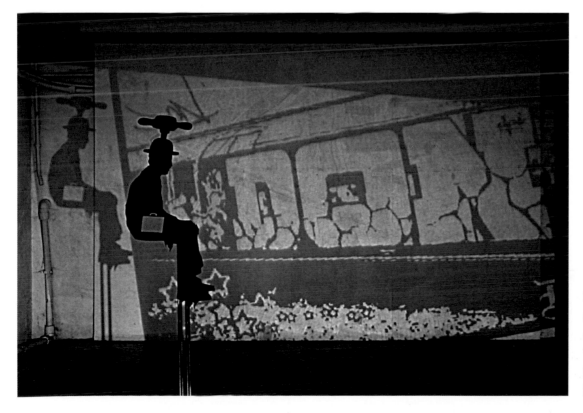

Urban art is edging indoors as tags and street pieces are projected onto walls. This image shows Paul 'DON' Smith's installation at the Electricians Shop in east London. Photo: Susan Mackey

ACKNOWLEDGMENTS

All photographs taken by the author, apart from where credited otherwise.

The author would like to thank the following:

Alba La Romaine
Simon Wisdom
Christian Durand
Diana & Lloyd Clater
Emma at Chateau d'Alba

Alghero
Massimiliano Caria

Azemmour
Anne Heslop
Abderrahmane Rahoule
Jean Jaques at Riad Sept

Bangalore
Meena Narayana

Barcelona
Montana Gallery sprayshop
Alejandra Raschkes at Mitte Gallery

Berlin
Doralba Picerno

Bogota
Dr Birger Herzog

Cadiz
Gry Graness
Ignacio Fando

Cape Town
Faith47
Mak1one
Sheridan Orr

Casablanca
Soukaïna Aziz El Idrissi and family
Valerie & Raphaël Liais du Rocher
Studio IWA
Morran Ben Lahcen & Mafoder

Delhi
Tom Sampson

Edinburgh
Anthony Johns
Matthew Kolakowski
Mirja Koponen at Total Kunst
Professor Ian Deary and his team at CCACE

Istanbul
Yeşim Korkmaz at Sultania

London
Icon
Stik
Ben Wilson
Ellis Leeper
Morris Wild
Gee Higgins
SixOneSix
Chloé Nelkin
Piper Gallery
Nick Joubinaux
Heashin Kwak at Hanmi Gallery
Susan Mackey
Paul 'DON' Smith
William Alexander
Ed Dempsi Fortune
Stephanie Sadler at
 Little London Observationist
Lindsey Clarke at Londonist
Urban Space Management
The Trustees of Trinity Buoy Wharf Trust
Alan Kirwan, Special Projects Arts Officer
 Borough of Kensington & Chelsea

Los Angeles
Victor Wertz
Peter & Tony Mackertich

Marseilles
Philip Hartigan of The Fine Heart Squad

Montreal
Roadsworth

Newcastle upon Tyne
Gordon & Tracy Taylor
John 'Jay Jay' Jobling
Richard Barber at South Tyneside Cultural
 Services

New York City
Jaime Rojo & Steven P Harrington
 at Brooklyn Street Art

Paris
Sylvie Vardon
Alan McKerl
Serge Dautheribe
Ernest Pignon-Ernest

Rome
Marcella Cottini
Felice Picerno

São Paulo
William & Herbert Baglione

Seoul
Jaye Moon

Tangier
Anuar Khalifi
Hicham Bouzid at Les Insolites
Michèle & Dominique Liegey at Dar Chams

Toronto
JULY i

Wellington
Bruce Mahalski
James Gilberd